COLOUR
Its Measurement, Computation
and Application

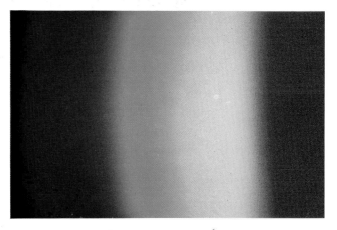

Frontispiece. The spectrum of white light.

COLOUR
Its Measurement, Computation and Application

G. J. CHAMBERLIN
and
D. G. CHAMBERLIN

LONDON · PHILADELPHIA · RHEINE

OPTOMETRY

Heyden & Son Ltd., Spectrum House, Hillview Gardens, London NW4 2JQ
Heyden & Son Inc., 247 South 41st Street, Philadelphia, PA 19104, USA
Heyden & Son GmbH, Münsterstrasse 22, 4440 Rheine, West Germany

British Library Cataloguing in Publication Data
Chamberlin, D G
 Colour.—(Heyden international topics in science).
 1. Colour
 I. Title II. Chamberlin, Gordon James
 535.6 QC495 79–41650

ISBN 0-85501-222-6

Typeset by CCC, printed and bound in Great Britain by William Clowes (Beccles) Limited, Beccles and London

CONTENTS

HEYDEN INTERNATIONAL TOPICS IN
SCIENCE

Editor: L. C. Thomas

FOREWORD

Colour is a subjective phenomenon which is so common a part of daily life that it generally receives little direct attention. However, even a little thought reveals the major, if often subconscious, role that colour plays in our assessment of the quality of life.

Colour: Its Measurement, Computation and Application, the second of the more general reviews in this Series, not only describes the physical and physiological basis of colour perception, and the assessment of deficiencies in colour vision, but also describes the methods used both for comparing colours and for defining colour in fundamental terms. The development of internationally accepted systems for colour measurement and definition enables a colour both to be specified and to be accurately reproduced from that specification. The CIE system of colour definition is described and illustrated in detail, and computer programs for the conversion of spectrophotometric measurements to CIE units are reproduced. These programs are written in BASIC and have been designed primarily for use by small laboratories having remote access to a time-sharing computer network. However the programs are discussed in such detail that they could readily be adapted by the reader to run on a relatively small, and cheap, microcomputer.

The book concludes with a review of some of the well-established applications of colour measurement, and contains numerous references to enable the reader to extend his studies to greater depth if required. This volume should be of assistance to all those engaged in the use, measurement, matching, control and specification of colour.

<div align="right">L. C. Thomas</div>

PREFACE

Interest in colour is worldwide in every section of the community, but for different reasons to different people. The artist looks at colour in a different way from the farmer, who uses colour to judge ripeness and disease: the housewife judges many of her purchases by colour for quality and appropriateness, while the printer has to get his colours right to stay in business.

Colour was used in the paintings of primitive cave-dwellers, and by warriors to make themselves terrifying to their enemies. Early civilizations and primitive peoples had a restricted range of colour-descriptive words, but was this because there was no need for them to be more precise, or because their range of available colours was smaller? Today, with heightened awareness of colour differences through the multiplication of dyes and pigments, and the need for standardization in mass production, scientists and research workers, manufacturers and colour-process workers, need some system of precise measurement and specification of colour.

Most people would give the credit for the beginning of a mathematical treatment of colour to Sir Isaac Newton in the early eighteenth century, but many before him had attempted an orderly classification of colours. It is in the late nineteenth and now in the twentieth century, however, with the sophistication of equipment, that great strides have been made.

The watershed is perhaps 1931, when the Commission Internationale de l'Eclairage first tackled the specification of colour on a mathematical basis for international use. Today some colour scientists are so immersed in their computer programs that colour is merely a matter of figures, and they 'do not waste time looking at colours'. What a world of pleasure they miss! Perhaps the greatest deprivation to a blind person is being denied that great joy of revelling in the world of colour.

This book endeavours to elucidate the mystery (which most of us take for granted) of how we see colour, then to indicate the various means adopted for its specification, and lastly to point out the vast range of human activity which is served by that accomplishment.

Salisbury G. J. Chamberlin
April 1980 D. G. Chamberlin

G. J. Chamberlin was Managing Director of The Tintometer Ltd, UK, until his retirement in 1972.
D. G. Chamberlin is Head of the Colour Division of The Tintometer Ltd and is currently seconded as Sales Manager with Tintometer USA.

ACKNOWLEDGEMENTS

We are grateful to The Tintometer Ltd for permission to reproduce Figs 3.12, 3.13, 3.14, 3.21, 4.20, 4.21 and 6.2; to Francis Dunstan of Perkin Elmer Ltd for providing the facilities for photographing the Frontispiece and Fig 3.17; Pye Unicam Ltd for permission to reproduce Figs 3.15 and 3.16; the National Bureau of Standards, Washington, DC, for Figs 4.16–4.19; and Messrs Bell & Hyman Ltd for Figs 3.10, 3.11 and 4.22. The late Mr D. G. L. Lovell drew the cartoons in Figs 4.10 and 4.13.

COLOUR: WHAT IT IS AND HOW WE SEE IT

1.1 METHOD OF COLOUR PERCEPTION

There is no such thing as colour in the absence of an observer; 'colour' is in fact a subjective sensation, experienced by an observer through the light-sensitive receptor mechanism of the eye. Hence, before what we call colour can have any meaning, light and an observer must be present. Sir Isaac Newton, a rich and necessary source of quotations on the subject, wrote over 300 years ago in his book *Optiks*; 'The rays [of light] are, to speak properly, not coloured. In them is nothing else than a power to stir up a sensation of this or that colour'. *Chambers Encyclopaedia* of 1741 tells us that: 'Colour is a property inherent in light, whereby according to the different sizes of its parts, it excites different vibrations in the fibres of the optik nerves which, propagated to the sensorium, affect the mind with different sensations.' Today, although using different words, we would say much the same.

Colour, therefore, is a special quality of a mental image perceived by an observer, which can be described by colour names.

Light is usually seen by reflection from or transmission by an object, which modifies the quality of the light and produces the concept of a 'coloured object'. If the light source itself is being considered, it is called a 'coloured light' if it departs from the norm of daylight, which we call 'white'.

The perception of colour may be broken down and discussed in four stages:

(1) The light source.
(2) The 'coloured' object.
(3) The eye with a colour-sensitive mechanism.
(4) The brain to interpret the energy messages received.

1.1.1 Light

What one recognizes as a natural white light is daylight (not direct sunlight, which is yellow, but sunlight reflected back from the sky), and light is that part

of the electromagnetic spectrum which falls between wavelengths 380 and 770 nm (1 nm = 10^{-9} m = 10 Å).

Newton first showed that daylight is really not homogeneous, but is a mixture of component bands containing a continuous contribution from radiation of each wavelength between these stated limits.

These component bands appear as different colours (see the Frontispiece), that is they produce sensations in the brain different from each other and different from the sensation of white which is the effect of the mixture. One can easily distinguish six entirely different sensations, which are named red, orange, yellow, green, blue and violet. These merge imperceptibly into one another, and thus there is an infinity of gradations. These bands of different wavelengths only produce a sensation of colour when they strike the eye—hence Newton's dictum that the rays themselves are not coloured. There is a remarkable consistency among people throughout the world in the perception of colours, so that there is no noticeable difference in colour perception between over 90% of humanity.

In real life one seldom meets the pure colour of radiation of a single wavelength (monochromatic radiation), but any disturbance of the normal balance in the proportions of energy in the different parts of the spectrum produces the sensation of a coloured light, because some part is emphasized at the expense of another. Thus by removing some parts of the continuous spectrum of light the conditions are produced for seeing colour. A light source itself may be coloured because it is deficient in some wavelengths, e.g. sodium light produced by an electric discharge through sodium vapour contains visible energy mainly at 589 and 589.6 nm, and hence causes the sensation of yellow orange. Many other gas discharge lamps which produce energy through atomic excitation are highly coloured for similar reasons. Incandescent lamps with metal filaments, e.g. tungsten, produce light as a function of the temperature to which the metal filament is raised, and this has a continuous spectrum of energy output which, although emphasizing the red and yellow part of the visible spectrum, is nevertheless acceptable as a warm white light source, although most of the energy produced is in the non-visible infrared region. Fluorescent lamps produce energy principally by the atomic excitation of mercury vapour, but the resulting gaps in the mercury spectrum are filled as well as possible by the fluorescence of the powders with which the inside of the tube is coated, and which are activated by the ultraviolet radiations of the excited mercury vapour. This gives an acceptable illumination, but the rendering of colours of objects is distorted because of the inequality of distribution of the energy throughout the visible spectrum. Two such lamps could give an equivalent colour appearance when observed direct, because differences between them balance out visually, and yet could render colours of objects differently, because one of them was deficient in some wavelength which was critical to the object. The more continuous the spectrum of a source in the visible range, the better the colour rendering, because it approximates better to daylight, our 'norm'. The colours of incandescent continuous-spectrum lamps can be specified by stating their

'colour temperature', which is the temperature of a non-selective ('black body') radiating light source of the same colour.[1,2] Such a radiator is a carbon tube externally heated to incandescence: the colour and spectral quality of the light from the inside surface of the tube are fully described by its temperature on the Kelvin scale. The colour appearance of a light radiating source can only strictly speaking be designated by its colour temperature when it has a spectral power distribution closely similar to that of a black body radiator (e.g. tungsten filament lamps and daylight may be so designated), but the colour of other light sources is sometimes quoted as the 'correlated colour temperature', this being the temperature of the black body radiation nearest in colour to the source under consideration or to quote the full definition: 'The temperature of the Planckian radiator whose perceived colour most closely resembles that of a given illuminant at the same brightness and under specified viewing conditions.' Non-emitting objects cannot have their colour specified in this manner.

1.1.2 The object

If an object reflects the whole of the incident light without discrimination it is called 'white', while if it is so constituted that it absorbs all the light it is designated black. Neither 100% absorption nor 100% reflectance are attainable in practice, but there is an infinity of gradations between black and white through grey in objects which are non-selective in their reflectance. This is called the achromatic range.

If an object has the inherent quality of differentially absorbing some part of the incident light and reflecting some other part, it will modify the light seen, giving only a selected part of the spectrum and causing the sensation of colour in the brain of an observer. If, for example, it absorbs most of the short wavelength part of the light (blue and green) and reflects the longer wavelengths only, it is seen as red or orange. A 'green' object absorbs the long wavelengths (red) and reflects the shorter wavelength end of the spectrum. One associates red with warm sensations, and as green objects absorb the red and reflect the higher (shortwave) frequencies, one thinks of green as a 'cool' colour.

Colour is therefore not an inherent quality of an object: its colour will depend on the illuminant by which it is viewed. What is inherent is its ability to absorb a particular section of the radiations in the visible spectrum, and to reflect others. As one normally sees objects in daylight, however, or an artificial approximation to daylight, the colour appearance of the object under these conditions comes to be regarded as 'the colour' associated with the object.

A tomato is recognized from its reflectance of the red end of the spectrum of daylight, and a lettuce as green from its reflectance chiefly of the middle wavelengths, but if both are viewed in a light containing neither 'red' nor 'green' wavelengths (e.g. sodium light) they will both appear grey or black. The greenness or blueness of an object will be greatly enhanced by seeing it in fluorescent lighting, which is rich in the shorter wavelengths owing to the

mercury vapour spectrum present, but a red object (e.g. meat) will look grey in such a light owing to the shortage of light at the longer (red) wavelengths. This despite the fact that the brain accepts the colour of the light itself as reasonably 'white', owing to its habit of integrating the sensations received into an overall average. One can say that such a lamp has excellent general lighting ability but is less successful at colour rendering.

1.1.3 The eye

Colour, as well as all other visual sensations, is brought to the brain through the eye. Light enters through the lens, which can alter its focal length through the operation of the ciliary muscles which alter the convexity of the lens, so that the image is focused onto the retina, the inner wall of the eyeball (Fig. 1.1). Immediately in front of the lens is the iris, a fibrous membrane which by expanding or contracting can control the amount of light entering the eye, thus compensating for sudden changes in the intensity of the light. The cornea is that part of the outer wall of the eyeball immediately in front of the iris. It is of shorter radius than the rest of the sphere, and, as well as affording protection,

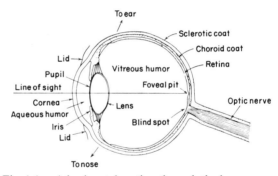

Fig. 1.1. A horizontal section through the human eye.

makes a major contribution to the refraction of the light. This combination of cornea and lens does not provide a perfect system, as it incorporates both spherical and chromatic aberration, but the brain has learnt to ignore the effects of these, and under normal conditions is not aware of these defects. A certain amount of infrared and ultraviolet radiation is absorbed by the ocular media, but excess can be very damaging. Hence special protective glasses are necessary in circumstances which produce high intensities of these wavelengths. The retina, on which the light image is focused, is a complex mosaic of millions of nerve endings containing a chemical substance which is bleached when exposed to light, giving rise to electrical energy which produces on/off impulses in the optic nerves.

This photochemical bleaching reaction is not destructive, as the visual pigment is regenerated continuously and almost instantaneously, although long

exposure to light produces a feeling of fatigue. If the light is too intense one is 'dazzled' and then regeneration takes appreciably longer: in the limiting case of looking directly at the sun the pigment may be permanently destroyed and then blindness results. Over most of the retina is found a type of nerve ending called a 'rod', some hundred million of them, which are rod shaped and register light 'on' or 'off' irrespective of the colour of the light. They are thus sensitive to movement, shape and texture, and are extremely sensitive to small amounts of light: so much so that one can see a match flame over a mile away on a dark clear night. It is by this sensitive rod vision that an observer can see objects not only by moonlight but even by starlight. However, rods only record light: that is, they see in black and white. They are connected together in bunches before reaching the interpretive part of the system, so that they achieve high sensitivity at the expense of fine resolution. At high levels of illumination, they play little part in vision.

In the centre of the retina is a small pit called the fovea (about 1 mm in diameter), in which there are no rod receptors but only 'cones', so called from their shape, and these are the nerve endings which provide colour vision. Here, instead of the bunching found in the rod area, there is a one-to-one connection with the optical system so that their resolving power is high and this is the area of distinct vision, lying on the visual axis of the eye. Some seven million of these cones are tightly packed in an area which subtends an angle of about 2° in the visual field. Hence, to distinguish fine details one must look straight at the object, so that its image falls on this area. This is done automatically by head and eye movements. However, cones require a higher level of illumination to bring them into action, and this threshold can be noted by slowly increasing illumination from darkness, through dim illumination when only shape can be distinguished (rod vision), until colour can just be perceived. This experiment covers the three stages of vision. Scotopic (when only rod vision is operating) mesopic (when the cones are just beginning to be stimulated and rods have not yet been flooded out), and photopic or full light cone vision. There are many complicated theories as to how cones function, but the simplest and most commonly accepted (due to Thomas Young 1773–1829 and subsequently supported by Helmholtz 1821–1894) is based on the experimental fact that any colour can be satisfactorily matched by a suitable mixture of three monochromatic radiations.

This trichromatic theory postulates three different types of cones, which are sensitive to different bands of wavelengths (Fig. 1.2), and the work of Wald[3] and of Marks, Dobelle and MacNichol[4] has placed the absorption peaks of these three classes of cones at about 430, 540 and 570 nm respectively, but all with wide and overlapping bands: Chander and Das[5] report the peaks rather differently at 480, 540 and 580 nm.

The 'red-sensitive' cones are thus brought into action chiefly by light of the longer visible wavelengths, the second type respond chiefly to light of wavelengths in the middle of the visual spectrum and are called 'green-sensitive',

while a third type (the 'blue-sensitive' cones) are most affected by light of the short wavelength part of the visible spectrum.

The visual pigments responsible for these various functions have not as yet been positively isolated. According to the trichromatic theory, when both the red-sensitive and the green-sensitive cones are activated and sending their respective responses, the brain interprets the message as somewhere intermediate in the spectrum and records a yellow sensation, either orange or yellow–green according to which message preponderates. Similarly, cyan (or 'turquoise' in artistic parlance) is the result of green and blue responses simultaneously. If all three types are stimulated at the same time, the message is white, although a continuous spectrum may not be present. This can be demonstrated by mixing

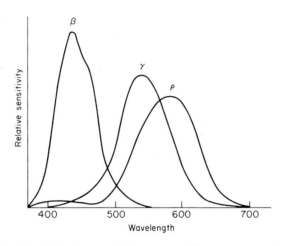

Fig. 1.2. Probable sensitivity curves of the colour receptors.

three beams of coloured light of quite narrow wavebands in the red green and blue areas: although it is clear that there are gaps in the spectrum, the brain will nevertheless insist that the result is white, although such a 'white' light will be quite inadequate in colour rendering properties.

The distribution of rods and cones changes as one travels outward from the fovea. The central area, which receives the image from an object subtending a field of 2°, is rod free. Outwards to a 4° field, there is a mixture of rods and cones, the composition of which mixture can vary with individuals. Hence it is stated that for the highest colour discrimination a field of only 2° should be used. (According to Helmholtz, a finger-nail at arm's length occupies a field of approximately 1°.) However, a 2° field is very small and difficult to use, and for practical purposes a 4° field is frequently employed in optical instruments. Outside this area the cone population falls off rapidly, and the periphery of the eye is not colour discriminating, although very sensitive to light variations, movement etc. It is because of this varying distribution of rods and cones

between individuals that there arises the slight difference in colour discrimination between 'colour normal' observers, but such differences are surprisingly small among over 90% of people, so that there can be general agreement as to colour matches in most cases. When using colour matching instruments subtending an area of over 4°, this phenomenon of 'rod intrusion' can cause some disagreement. There is still considerable disagreement as to the precise point in the visual system at which the colour coding takes place, whether in the photoreceptors themselves[6] or at some intermediate point between there and the visual cortex of the brain.

Another theory of colour vision is advocated, known as the 'opponent colour' theory of Ewald Hering (1834–1918), in which one type of response is sensitive to variations between the opposite primaries red and green, another type records the part played by the opposing yellow and blue content, while a third response is black/white (i.e. brightness). This theory thus assumes that there are six different unitary sensations (red, yellow, green, blue, white and black), no one of which partakes of any other: for example, yellow is regarded as a basic colour, and not a mixture of red and green sensations.

It was suggested by Von Kries that the visual process proceeds in two stages, i.e. that the trichromatic theory is valid at the receptor level, but that the signals from the receptors are processed at some later stage into the opponent colour system, and the work of Hurvich and Jameson[7] over the last twenty years seems to corroborate this idea. This compounding of the two colour vision theories helps to explain a great deal of the mechanics of the subject, but exactly which theory is most helpful depends on what is the prime object of the study.[8] When one is concerned with physiological and psychological research, the opponent colour or the two stage theory helps to explain much not satisfactorily covered by the simple trichromatic theory. When, however, one is concerned solely with the mathematical technicalities of colour measurement, the trichromatic theory undoubtedly fits the experimental facts and has been adopted in the international concept of colorimetry—especially because it makes it possible to characterize colours by their position in a Maxwell triangular plot.[9, 10] No one theory at present satisfactorily explains all the observed facts and theoretical considerations, and, until a theory is produced which is universally applicable and acceptable, colorimetrists must continue to use what has been accepted by general consensus.

The trichromatic theory also offers a very simple explanation as to why some people are weak in colour discrimination. Such people are popularly referred to as 'colour blind', but that is a misnomer, and they are properly labelled 'colour deficient'. In terms of the trichromatic theory, it would seem that one of the types of cones is not functioning normally, or even is absent altogether. As one would expect, there are three variations among those people (dichromats) who have only two types of cones functioning: protanopes, who are largely deficient in red responses; deuteranopes, who are largely deficient in green responses; and tritanopes, who are deficient in blue responses. These can match colours to

their satisfaction by mixtures of the other two primaries alone. If there is only reduced efficiency in one of the responses, they are called anomalous trichromats—thus protanomalous, deuteranomalous, or tritanomalous—and they will make matches with varying mixtures of the three primaries, or will accept as matches colours which are mismatches to normal observers.

Such colour deficients (males only) have been quantitatively classified, as percentages of the male population, by Wright[11] as:

	(%)
Anomalous trichromats	5.4
Dichromats	2.7
Monochromats (Only black and white, no colour discrimination)	0.003
	8.103

Various methods have been devised to identify these abnormalities. These are discussed in Chapter 2. However, it must be emphasized that the incidence of these deficiencies is much rarer than is popularly supposed. Completely colour blind subjects are rare indeed. Colour deficiency is hereditary, and can be passed to her sons by a mother who has inherited such a recessive gene from her parents, but this disability only rarely appears in a female, and only when there is a history of this in the families of both her parents. Less than 0.5% of females have other than normal colour vision.

1.1.4 The brain

Although an image may be formed on the retina, the observer cannot be said to 'see' unless that image is in some way conveyed to his consciousness. A train of impulses is set in motion by the light, and these messages have to be conveyed to, and interpreted by, the brain before perception occurs.

The electrical impulses set up in the rods and cones are programmed and sorted out somewhere on the way to the brain, but there is no general agreement as to the mechanism of sorting. Some suggest that a commencement is made with coding in the retina itself, or in the tissues and nerves immediately adjacent to it, or at intermediate points where the nerve ganglions join to form bundles of pathways. However, some form of message is eventually conveyed by the optic nerve to the appropriate part of the brain, the messages from the rods telling of light or no light (i.e. shape, movement etc. in dim lighting) while the cone messages convey information which gives rise to the sensation of colour as well as form. On reaching the brain, the messages are decoded and referred, as in a computer, to a bank of stored memories, which will connect the picture presented with something previously experienced, and finally the sensation of something 'out there in front' materializes in the consciousness. The object is outside, the experience is in the brain, but the two become associated for future

reference. Because the two eyes see the object from slightly different angles, the 'picture' is 3-dimensional.

All this wonderful and involved operation is carried out at lightning speed and taken for granted, and it is only when something goes wrong that the matter is given any thought. When the eyes 'play tricks', such as for example in optical illusions, this usually means that the observer is trying to form a conclusion from insufficient evidence or from something 'not in the records', and a guess is made which proves to be wrong. All through our waking hours we are presented with an avalanche of messages from our eyes which would overwhelm us if the brain were not selective, ignoring what is not relevant. We only perceive those things in which we have an interest, or which our brain automatically brings to our notice because of our built-in instinct for self preservation.

The artist will perceive the beauty of a display of fruit in a shop, while the housewife will note only the prices: a fashion-conscious woman will note the colour or design of a frock, while a 'mere male' may notice only a shapely pair of legs beneath. Any sighted person will, however, perceive a motor car bearing down on him and jump back onto the path automatically.

1.2 COMPLICATIONS IN COLOUR PERCEPTION

1.2.1 Chromatic adaptation

Within limits, the brain can make allowances for changes in the light radiations which reach the eye from an object, because it has learnt that things do not change in an arbitrary fashion. Going from daylight into a room lit only by incandescent lamps, one is seldom conscious of the fact that the colour of everything has changed, although reason points out that this must be so. One learns to judge relatively, so that any object which reflects all the incident light is seen as white. From that reference point, other objects fall into place with their relative colours, and one can accept what is seen as the 'normal colour'. If however, the illumination is completely deficient in some parts of the spectrum, (e.g. some forms of fluorescent lighting), certain objects will appear in wrong colours because they are unable to reflect their most distinctive parts of the spectrum, those by which they are normally recognized.

1.2.2. Metamerism

This has been defined as a non-spectral match. It is quite possible for two objects to reflect a different selection of wavebands and yet for the various 'pluses' and 'minuses' to cancel out and create the impression in the mind of an observer that they are the same colour when viewed in a certain light. If the illuminant is changed, the new one will itself be made up of a different selection of wavebands (in technical terms, will have a different spectral energy distribution), and hence the delicate balance is disturbed and the two objects are no longer seen as a match.

Figure 1.3 shows the spectral energy distribution curves of two green–brown cloths which appear to match in daylight, but which are quite different in appearance in tungsten light.

Such a pair is called a metameric match. The same reasoning can be applied to two coloured light sources, which appear to match until they are viewed through a colour filter. It is such metameric pairs which may cause arguments between observers, and this phenomenon is used as a very sensitive test of colour abnormality.

An example of such a test is the Davidson and Hemmendinger Color Rule, which contains two colour scales, one being compounded of orange and blue dyes and another of violet and green, graduated from one extreme to the other.

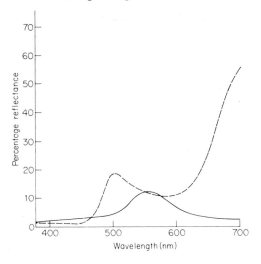

Fig. 1.3. Spectral reflectance curves of two metameric samples.

Most people can find a point of approximate match somewhere between the two. This rule can be used to compare the colour vision of two observers in the same illumination, or the difference in colour rendering of two illuminants when only one observer is used.

If two objects have exactly identical spectral reflection characteristics, they will continue to match whatever the illuminant, because their apparent colour changes will be the same.

1.2.3 Dichroism

An object which is viewed by transmitted light, either a transparent solid substance or a liquid, may exhibit different colours according to the thickness of sample viewed. For example, blood is yellow if viewed in an extremely thin film, but changes to red in greater depth: Chartreuse liqueur is green in a thin film, but red in greater depth: water is colourless in a few centimetres depth, but

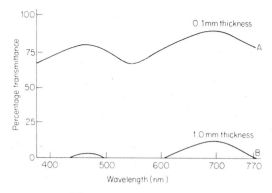

Fig. 1.4. Dichroic colour.

Fig. 1.5. The grey tape is continuous in colour throughout, but appears to change colour against the different coloured backgrounds.

blue or green in a depth of two metres. This phenomenon of 'dichroism' is most easily explained by a diagram (Fig 1.4). The two colours are present as peaks in the spectral energy distribution curve, but one or other predominates according to the depth viewed (i.e. the concentration of the colour). At 0.1 mm thickness of sample (A) the general visual effect will be minus blue (i.e. yellow), but at 1 mm thickness (B) only the long wavelength transmission will be effective, and the visual colour will be red.

Another phenomenon of colour is Simultaneous Colour Contrast, or Induction, by which adjacent colours can influence each other and produce a perceived difference. For example, two patches of the same colour on differently coloured backgrounds will appear different when viewed simultaneously (Fig. 1.5), although they can be shown to match when the backgrounds are masked out.

REFERENCES

1. Deane B. Judd and G. Wyszecki, *Color in Business, Science & Industry*, 3rd Edn, Wiley-Interscience, New York, 1975, p. 164.
2. F. Grum, S. B. Saunders and D. L. MacAdam, Concept of Correlated Color Temperature, *Color Res. Appl.* **3** (1) 17 (1978).
3. G. Wald, The receptors of human color vision, *Science* **145**, 1007 (1954).
4. W. B. Marks, W. H. Dobelle and E. F. MacNichol, Vision pigments of single primate cones, *Science* **143**, 1181 (1964).
5. M. Chander and S. R. Das, Trichromacy of colour vision under transient adaptation, *Colour 73* (Report of 2nd Congress of the International Colour Assn.), Adam Hilger, London, 1973, p. 274.
6. W. E. Crandall, Digital Retinal Vision Theory, *Colour 73* (Report of 2nd Congress of the International Colour Assn.) Adam Hilger, London, 1973, p. 265.
7. L. M. Hurvich and D. Jameson, Further development of a quantified opponent colors theory, *Visual Problems of Colour*, Vol 2, NPL Symposium No. 8 London, 1957, p. 693.
8. D. B. Judd, Fundamental Studies of Color Vision from 1860 to 1960, *Precision measurement and calibration*, Special Publication 300, Vol. 9, National Bureau of Standards Washington DC, 1972, p. 81.
9. W. D. Wright, *The measurement of colour*, 4th Edn, Adam Hilger London, 1969, p. 44.
10. H. Kalmus, *The diagnosis and genetics of defective colour vision*, Pergamon Press, London, 1965, p. 4.
11. W. D. Wright, *Researches on Normal and Defective Colour Vision*, Henry Kimpton, London, 1946.

METHODS OF DIAGNOSING AND ASSESSING COLOUR VISION DEFICIENCIES IN OBSERVERS

2.1 NAGEL ANOMALOSCOPE

The classic instrument for assessing abnormalities of colour vision was modified by Nagel in 1907, from an instrument devised by Rayleigh, and consists of a prism to split white light into its spectrum and an optical arrangement to provide an optical field viewed through an eyepiece, one half of which is illuminated with yellow light from this spectrum. The other half of the field consists of a mixture of the red and green parts of the spectrum. The observer is required to match the yellow by altering the proportions of red and green in the other field. The extent of his defect is judged by the amount by which he introduces excess red or green as compared with the reading of a range of normal observers, and also by his reliability in repeating his observations. This will only disclose protanomaly (red deficiency) and deuteranomaly (green deficiency) and is useless in the case of tritanomaly (blue deficiency), but as there are very few tritanopes encountered, this is of little importance in practice. Less precise, but less costly, are versions of this anomaloscope using filters to produce the red, yellow and green colours, such as that devised by Pickford.[1]

2.2 ISHIHARA CHARTS

Perhaps the best known and most widely distributed colour-vision test is that due to Ishihara.[2] This consists of a series of colour plates in which numbers are outlined in dots against a background of dots of a different colour: the colours are so designed as to cause confusion to an observer with sub-normal colour acuity. He may read the numbers with difficulty, see no number at all, or even read a wrong number and the plates have been designed to confuse all standard types of colour deficients. Colour normals have no difficulty whatever in reading the numbers correctly. The test must be supervised by someone who understands it thoroughly, and under strictly controlled conditions of lighting and viewing.

There are many other versions of this type of coloured dot test, such as the Stilling, Bostrum, American Optical Company and Tokyo Medical College Charts.[3,4]

2.3 COLOUR SELECTION TESTS

Many tests are based on the idea of asking the observer to sort out a mixture of assorted coloured objects into a closely graded series, and he is marked on the number of mistakes made. Some of the earliest were those due to Charles Roberts[5] and the Holmgren coloured-wools test.[6] The most widely used of this type today is the Farnsworth–Munsell 100-Hue Test.[7] The Hardy Rand Rittler test[8,9] ('HRR') is no longer produced, but many copies are still in use in research laboratories.

2.3.1 The Farnsworth–Munsell 100-Hue test

The Farnsworth–Munsell 100-Hue Test was devised by Commander D. Farnsworth in the early 1940s, and is now extensively used for colour vision testing as well as for assessing both colour discrimination and colour grading ability. The test consists of some 85 Munsell papers which are mounted in plastic caps for ease of handling, and each member of the sequence is identified by a number which is seen when the cap is turned over.

In the Munsell colour system, the hue circle is divided into a total of 100 separate hues, while the current Books of Color show only 40 of these different hues. Farnsworth's original intention was to select samples showing each of the 100 possible Munsell hues, all having the same value and chroma. Careful series of measurements led Farnsworth to choose only 85 of the original samples examined as these represented the most equal spacing possible around the hue circle. Nevertheless, the name of '100-Hue Test' has persisted and is well known the world over.

In practice the complete set of colour caps is held in four trays. Each of these trays has a fixed or pilot cap at both ends while the remainder of the colour caps are presented to the subject in random sequence in the lid. The subject is asked to pick out the colour cap which exactly matches either one of the fixed end caps in the tray and then to pick out the one which most closely matches the colour just chosen. In this way the subject builds up a sequence of colours which will be correct for him.

To score the test, the examiner closes each tray in turn and flips it over to reveal the numbers on the underside of each cap. He records the sequence of numbers chosen and then makes a note of the sum of the differences between each number and those of its two neighbours. These results are recorded on a polar chart, such that a perfect sequence will always give a difference of two and would yield a perfect circle. Any deviation from a correct sequence will show up as a spike on this plot and it is the size and orientation of these spikes which allow the examiner to diagnose a particular colour defect and its likely extent.

2.3.2 Farnsworth dichotomous ('D₁₅') test

Some years after his original work, Farnsworth devised a simplified version of this test which was more suitable for large scale screening. This test consists of an array of 15 colour caps contained in a single tray and with a pilot cap at the left hand side. The subject is given the tray in which the colour caps are arranged in random sequence in the lid as before. He is asked to find the colour which most closely matches that of the pilot cap on the left, and then the one which most closely matches the one he has just chosen and so on. The hue spacing is very much wider than in the 100 Hue test and all subjects with normal or nearly normal colour discrimination will have little difficulty in arranging the caps in their correct colour sequence.

Fig. 2.1. The D₁₅ colour vision test.

As before, the examiner scores the test by reversing the caps in order to record the sequence of numbers chosen. These numbers are again recorded on a polar chart yielding a series of lines which again allow the examiner to decide which type of colour vision defect the subject may show.

The examiner may now give the subject another cap containing a Munsell neutral of the same value as the other test colours. The subject is asked whether he can fit this cap into the sequence he has chosen and, if he can do so, this will assist in the diagnosis of the type of defect.

2.3.3 City University Colour Vision test

Another type of test has been advocated by Prof. R. Fletcher in the City University Colour Vision Test,[10] made by Keeler Instruments of London. On each page is a central test colour surrounded by four confusion colours specially selected to identify different types of colour deficiency.

2.4 INSTRUMENTAL METHODS

An entirely new approach has been made by Professor R. W. G. Hunt and Dr Stephen Dain[11,12] in the Lovibond Colour Vision Analyser, which uses the unique advantage of coloured filters (i.e. the Lovibond glasses) to alter the saturation of the sample colours at will, by means of a specially devised optical system. This can thus display all the colours in the hue circle at any saturation from full to a near-white desaturated colour, and this allows a diagnosis to be made of the extent as well as the type of colour deficiency. This instrument is not programmed for standard types of colour deficiencies, but can detect any type of abnormality whether inherited or acquired, and however unusual. The subject sits facing a screen on which are displayed a small illuminated circle surrounded by 26 illuminated circles covering the complete colour gamut in random order. He is asked to rotate the colour circle until he finds one of the spots of light in it which matches the spot in the centre. The examiner can alter the saturation of the colours optically, from high saturation to almost white. From the saturation level at which a firm answer can be given (there is in fact only one correct answer, as the centre circle is grey and there is one grey in the colour circle), and from which colours are selected to match the grey, a complete picture can be obtained (and assessed quantitatively) of any colour abnormalities. This instrument is made by The Tintometer Ltd, Salisbury, UK.

2.5 TRADE TESTS

In many cases, the only reason for a test is to check an applicant's ability to carry out a specific task, and in such a case tests have been devised for just this purpose. The Board of Trade lantern, for example, is used for testing pilots and navigators by sea and air, and it displays lights of various colours, sizes, and brightnesses which must be named correctly in rapid succession and under various conditions of viewing. The first model was designed by Edridge Green in 1891 and adopted by the Board of Trade in 1909. A new model was adopted in 1912. This is also used for engine drivers and others who need to distinguish coloured signals. The Martin Lantern is a more recent development of this test (1933, revised in 1939, and adopted by the armed forces). The Giles Archer Colour Perception Unit is also a lantern test, with three sizes of aperture and two colour filters each in red and yellow and three in green. One of each colour corresponds to the Civil Aviation Authority's specification, and one of the greens is a blue–green signal colour. This unit classifies candidates as Normal, Colour Defective Safe, or Colour Defective Unsafe, and was primarily used by the Royal Air Force during the 1939–45 war.

In 1975 the Holmes Wright lantern was adopted by the Armed Services, the Merchant Navy, and the Civil Aviation Authorities. This shows one white signal representing a colour temperature of 2856 K (Illuminant A of the CIE system), two red (one orange–red and one equivalent to railway red) and two green (one yellow–green and one blue–green). It can be adjusted to 3 luminance levels, but in each case all 5 colours are of equal photopic intensity, to avoid giving any clues to a colour-deficient subject. The colours are viewed one above the other to avoid confusion between 'right' and 'left', and the subject has to name the colours without hesitation.

The need for such tests is obvious in industries and professions where an ability to match or distinguish colours is called for, and in some cases the safety of both the operator and others is at stake—for instance in the coding of electrical circuits or cylinders of gases or in the reading of transport signals. It has been realized today, additionally, that the testing of school children is imperative, so that they may learn early if they have this disability, and avoid training for some occupation from which they would subsequently be debarred on colour vision grounds.

At the 4th Symposium of the International Research Group on Colour Vision Deficiencies, held in Italy in 1977, a review of all available methods of testing for such defects was made, and comments will be published in due course by a working party then appointed. However, one of the participants has published her own recommendations.[13]

REFERENCES

1. R. W. Pickford and R. Lakowski, The Pickford Nicholson Anomalascope, *Br. J. Physiol. Opt.* **17**, 131 (1960).
2. Shinobu Ishihara, *The Series of Plates designed as a test for colour blindness*, Kanehara Shuppan Co. Ltd, Tokyo.
3. K. Umazume, R. Seki and S. Obi, Studies on trial production of new color vision test plates, Report 1, *Acta Soc. Ophthalmol. Jpn* **58** (8), 732 (1954).
4. K. Umazume, R. Seki and S. Obi, Studies on trial production of new color vision test plates, Report 2, *Acta Soc. Ophthalmol Jpn* **59** (7), 765 (1955).
5. C. Roberts, *The detection of colour blindness and imperfect eyesight with a table of coloured Berlin wools*, J & A Churchill, London, 1884.
6. Holmgren, *Om några nyare praktiska metoder att upptäcka fargblindheit*, Uppsala, 1978.
7. D. Farnsworth, The Farnsworth–Munsell 100 Hue and Dichotomous tests for color vision, *J. Opt. Soc. Am.* **33**, 568 (1943).
8. Hardy Rand and Rittler, The HRR polychromatic plates, *J. Opt. Soc. Am.* **44**, 509 (1954).
9. G. Walls, How good is the HRR test?, *Am. J. Optom.* **36**, 169 (1959).
10. R. J. Fletcher, A modified D15 test, *Modern Problems in Ophthalmology*, No. 11, Skarger, Basel, 1972, p. 22.
11. S. J. Dain, A new colour vision test, Unpublished Ph.D. Thesis, City University, London, 1971.
12. J. S. Ensell, Experience with the Lovibond Colour Vision Analyser, *Color Res. Appl.* **3** (1), 11 (1978).
13. J. Voke, *Guidelines to industry and the professions on colour vision testing and requirements*, Keeler, London, 1979.

THE MEASUREMENT OF COLOUR

3.1 THE ATTRIBUTES OF COLOUR

Before discussing its measurement, one may usefully consider the attributes of this sensation which it is hoped to measure.

'Colour' (which is that attribute of visual perception which can be described by colour names) can be produced by the synthesis of various sensations experienced at the same time. The addition of a red message at the same time as a green message produces the sensation of yellow: this happens when a red light and a green light impinge on the same spot in the retina simultaneously. If red, green and blue lights are mixed the effect is white, as has already been discussed. This is known as the 'additive mixture' of lights, and the primaries used are the same as the responses of the cones of the trichromatic theory. Colour can also be produced 'subtractively' by an object which absorbs some part of the incident white light and only transmits or reflects a part. This is the commonest method of producing the sensation of colour, and is seen whenever one looks at the world. These primaries, which are used in mixing dyes and pigments, are magenta (a mixture of blue and red sensations) cyan (a mixture of blue and green sensations) and yellow (a mixture of red and green sensations), and to reconcile these apparently contradictory methods of using the word 'primary', consider light which is modified by coloured filters. Incidentally, exactly the same procedure happens when a colour is produced by reflection from a coloured object.

A white light falling on a magenta filter has all the green part absorbed and only blue and red transmitted. With a cyan filter all the red is absorbed, and green and blue transmitted. With a yellow filter, all the blue is absorbed, and the red and green transmitted. (See Fig. 3.1 (a–c).) If these filters are used in pairs, a further subtraction takes place, leaving us with one of the three additive primaries. (See Fig. 3.1 (d–f).)

If beams of the additive primaries are mixed by projection onto a white

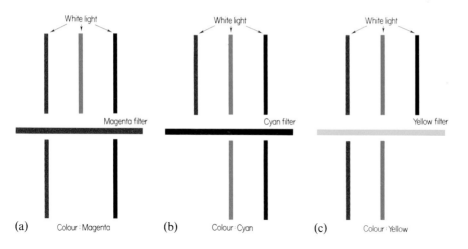

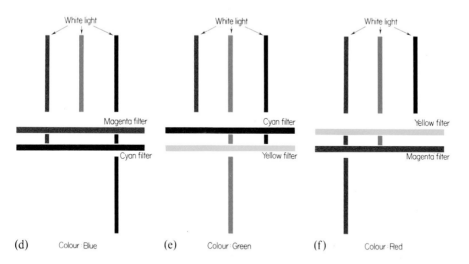

Fig. 3.1. (a) White light falling on a magenta filter has all the green part absorbed and only blue and red transmitted. (b) With a cyan filter all the red is absorbed, and green and blue transmitted. (c) With a yellow filter, all the blue is absorbed, and the red and green transmitted. If these filters are used in pairs, a further subtraction takes place, leaving one of the three additive primaries (d–f).

screen in a dark room, copying Thomas Young's experiment, both sets of primaries are produced, and white appears where all overlap (Fig. 3.2).

If the subtractive primaries are mixed as pigments, the same six colours appear, but with black in the middle instead of white, because all light has been absorbed (Fig. 3.3).

There are several unusual ways of producing colour which at first sight might appear to come into a different category, such as interference, polarization, and diffraction methods, but these can all be explained as variations of subtractive colour formation from white light.

In the foregoing discussion on filters, it is an oversimplification to assume that *all* the red or green or blue was absorbed. This would only happen with a very highly saturated colour. If each filter transmitted some of all colours, but more in a particular part of the spectrum, this would mean that it was transmitting white light with an excess of some particular colour, and a pastel or desaturated colour would result. The same applies to a pastel-colour reflecting surface. In mixing coloured lights, a desaturated colour is seen if all three lights are shining on a given spot but in unequal proportions. This leads to the fact that to describe a colour in quantitative terms, whatever kind of quantification is employed, one must perforce use three dimensions.

First, one must describe or quantify the *hue*—the kind of colour it is—red or yellow or green: this fixes it in its position in the spectrum, and tells its relation to other colours. In words, one may apply a qualitative adjective such as 'yellowish-red' to help fix the position more clearly. Next, it is necessary to find a way to describe its *saturation* or *colourfulness*—strength or purity or richness, judged in proportion to its brightness. A 'highly saturated red' means light from only the red part of the spectrum, not diluted with light of any other colour. In 1861 James Clerk Maxwell adopted the idea of a colour triangle from Thomas Young (1773–1829).

If highly saturated coloured lights are placed as in the diagram (Fig. 3.4), mixtures of any two primaries will be found on the lines joining the apices, and these colours will all be fully saturated. In the centre, where all three are in equal balance, will be white. At any point between white and the triangle sides will be found a colour plus white, i.e. a desaturated colour, and as a line or apex is approached the colour becomes less contaminated with white and more saturated. Within the Maxwell triangle can be found every kind of colour quality (hue and saturation), but there is a third dimension needed to complete the specification, and this is its brightness, which cannot be expressed in a plane two-dimensional diagram. Hue and saturation define 'colour quality' or 'chromaticness' but three dimensions define 'colour'. This third dimension, which is called *brightness*, or in the case of a non-luminous object, *lightness*, is sometimes described as the position of the colour as compared to a black to white scale. It means the relative amount of light reflected by the coloured object compared to white under the same illumination and the higher the brightness the more 'alive' and clear the colour appears. This can be measured

as a percentage by a photoelectric cell as light flux output compared with a white surface under the same illumination. In the case of a transparent object, it will mean the percentage of the incident light which is transmitted.

Thus 'colour quality' can be expressed in a plane diagram as on p. 54 but the sensation of colour is three dimensional and must be seen as a solid figure when discussed mathematically.

One cannot, strictly speaking, *measure* colour instrumentally, because it is a subjective sensation. What can be done is to *describe* colour in idealized and standardized terms, using numbers which can be correlated with visual images. In every day conversation, one compares colours to some readily understood physical standard, e.g. orange, lemon, cream. In choosing numbers, which are precise and above language barriers, one has to define the conditions of observation very fully—but it is seldom that such ideal conditions exist exactly in the everyday world of visual colour apprehension.

3.2 COLOUR MEASUREMENT

Two different but broad avenues of approach are used in defining and measuring colour. These are:

(1) Visual comparison with some known physical standard which is accepted as a reference; or
(2) Instrumental measurement of the fundamental make-up of the constituent parts of the colour in terms of relative amounts of each wavelength present. This gives an unequivocal 'finger-print' of the colour, but to turn this into a visualizable description of what the colour looks like, one has to find a way of relating these basic stimuli to the colour image which would be produced by this stimulus in the brain of a hypothetical 'standard observer'. In order to do this, a system has been developed defining both the exact conditions of illumination and observation, and how one would expect such an observer to react.

Note that, in both cases, an observer (real or hypothetical) must be included—because colour is a subjective sensation.

3.3 VISUAL COMPARISON SYSTEMS OF COLOUR DESCRIPTION AND DEFINITION

The simplest and oldest procedure is to produce a kind of colour catalogue which is systematized and accurately reproducible. Such catalogues are called *Colour Atlases* and are known as Colour Appearance Systems. There have been very many of these, and any list is bound to be incomplete. Some of the best known are described below.

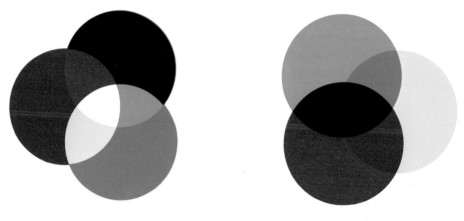

Fig 3.2. Additive mixture of coloured lights. Fig. 3.3. Subtractive mixture of pigments.

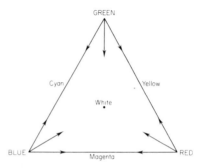

Fig. 3.4. Maxwell colour triangle theory. (A colour plate developed from this scheme is illustrated in Fig. 4.5.)

3.3.1 The Munsell book of colour

It was first produced in the USA in 1905, and subsequently revised and improved many times.[1,2] It now contains well over 1500 systematically ordered actual colour samples which are precisely defined and reproduced. In use, the sample 'chips' and the coloured sample are compared, against a neutral background, by daylight or a permitted alternative, and an assessment made of the position of the sample in the colour solid. In its idealized conception, any sample is uniquely described by finding the nearest equivalent in the atlas for hue, value (the name given by Munsell to its luminosity or lightness related to an achromatic series from black and white) and chroma (the Munsell name for saturation of colour). The Munsell concept of colour space is illustrated in Fig. 3.5.

The hue circle (Fig. 3.6) is divided into 5 principal hues, red (R) yellow (Y) green (G) blue (B) and purple (P). Chroma is the distance out from the achromatic axis, and value is the adjudged equivalent lightness to one of the vertical steps from black to white. The 5 principal hues are augmented by 5

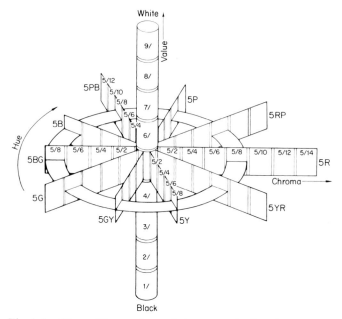

Fig. 3.5. Munsell hue, value and chroma scales in colour space.

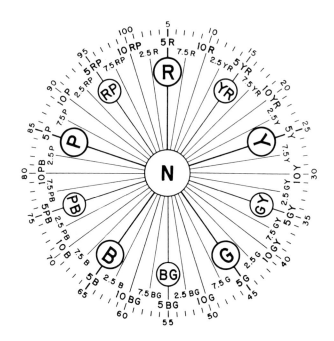

Fig. 3.6. Munsell hue circle.

intermediate hues, and these portions are subdivided into 10 divisions, giving 100 hue divisions in all. At different value levels the choice of pigments available to represent the hue and chroma steps will vary, so that the solid is perforce very irregular (Fig. 3.7), with many gaps, which are filled from time to time in new editions as other pigments become available. The steps of chroma and value are arranged at equal perceptual intervals.

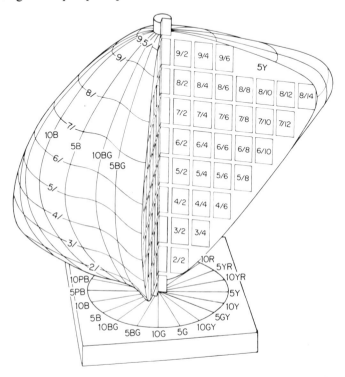

Fig. 3.7. Munsell colour solid cutaway to show constant hue 5Y.

Atlases containing the complete gamut of Munsell colours are published in both matt and glossy samples, the latter allowing for higher chroma values in many cases. Specialized collections of colours are also available, such as those for Soil Colours and numerous industrial applications. A form of colorimeter is also made for surface colours, and is known as the Munsell colour spinning device (Fig. 3.8). It is based on the phenomenon of persistence of vision: if a mixture of coloured segments is rotated in front of the eye sufficiently fast for the effect of one colour not to have faded from the memory before the image of the next colour is thrown on the same retinal area, the colour images blend into an 'average' sensation in the brain, and this build-up of colours follows the principle of additive mixture of coloured lights. For example, if a circle of coloured segments is rotated sufficiently fast, one half of which is red and the other half green, the visual effect will be a circle of yellow or orange colour, as when

coloured lights are mixed. All three primaries, red, green and blue together will give dark to light grey if appropriately proportioned, but neither black nor white can be achieved this way because the pigments cannot wholly absorb or reflect the incident light. By superimposing overlapping circles of Munsell papers and rotating these on a platform mounted on the spindle of a motor, it is possible to match any hue and chroma visually by a suitable choice of pairs and the adjustment of the relative proportions exposed. The value is adjusted by the addition of black and/or white segments. The angular sizes of the adjusted segments are reported as the colour formula, and this can be reproduced at will. The illumination must be agreed and carefully controlled. This method is much used in the food industry: from this segment formula an actual specification for a single colour in the *Munsell Atlas* can be derived, and a simple colour chip can then be used in subsequent grading work.

Munsell specifications can be converted into the basic CIE system of colour designation (see Chapter 4) by means of conversion graphs (Fig. 3.9).

3.3.2 The Ostwald system

This was formulated in 1917 by Wilhelm Ostwald, is based on copying with colorants the colour-mixtures produced by systematically varying the component primary colours in a rotating disc colour mixer of the Maxwell type, and is designated a colour-mixture system. From Ostwald's work,[3] the *Colour Harmony Manual* was developed by the Container Corporation of America in 1942. The gamut is obtained by the use of optical mixing instruments and not on any simple perceptual basis. The Ostwald colour solid (Fig. 3.10) has a vertical axis of black to white as in the Munsell system, but any vertical section is a uniform diamond shape with the triangular areas each side of the axis containing complementary colours. Each such area is in theory laid out with colour samples divided by diagonal lines to show constant black and constant white content, with full colour content increasing radially. It is thus the result of instrumental experiments, and not based on perceptual intervals. It is of interest in showing the effects of mixing black, white, and coloured pigments and in illustrating complementary colours, and in facilitating the study of colour harmony. It does seem that as a matter of national prestige many countries have at one time or another produced their own colour atlases with claims that they are better, or serve some specific purpose better.

3.3.3 The DIN system

In Germany Dr Manfred Richter produced the DIN (Deutsche Industrie Norm) colour system.[4] It originally contained some 160 gelatine samples, but a decade later it was matched in paint to produce a colour atlas. It has many similarities to the Munsell system, but hue is assumed to be dependent on dominant wavelength, and in place of value there is a 'relative lightness' scale which has

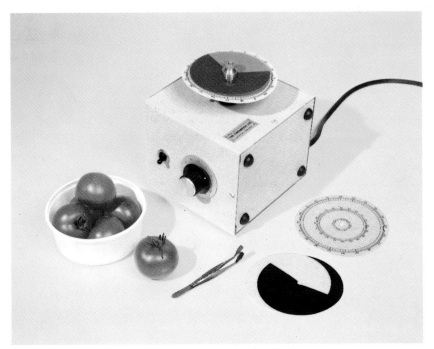

Fig 3.8. Munsell colour spinning device.

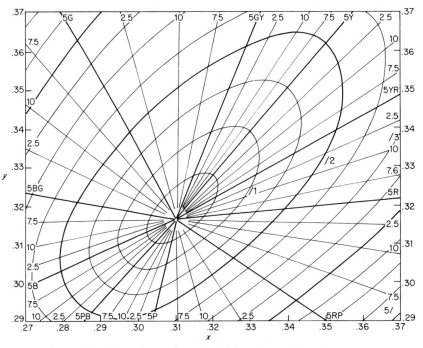

Fig. 3.9. Conversion chart, Munsell to CIE system.

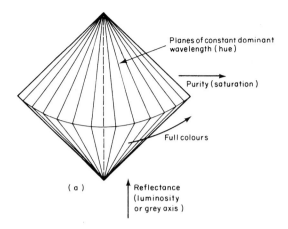

Planes of constant dominant wavelength (hue)

Purity (saturation)

Full colours

(a)

Reflectance (luminosity or grey axis)

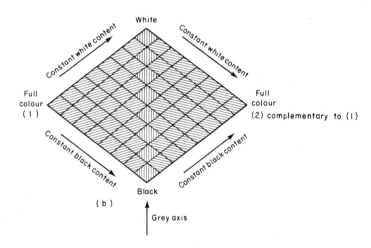

White

Constant white content

Constant white content

Full colour (1)

Full colour (2) complementary to (1)

Constant black content

Constant black content

Black

(b)

Grey axis

Fig. 3.10. (a) Ostwald colour space; (b) vertical section of two sets of coloured surfaces of complementary dominant wavelength.

a somewhat complicated mathematical definition which precludes any simple relationship to the Munsell system. However, a complete specification in the Munsell and CIE systems was subsequently issued.[5] In Sweden, the Natural Colour System has been formulated,[6,7] which follows similar lines to the work of Professor Sven Hesselgren. It is based on direct empirical visual estimates of the relative amounts of 'absolute' blue, green, yellow, red, as one progresses round the colour circle, while black to white are as usual on a vertical axis. The work of producing this atlas was undertaken by the Swedish Colour Centre. The relationship between this and the Munsell system was discussed in papers by Judd and Nickerson in 1973 and 1975.[8,9]

3.3.4 Other systems

In Denmark, Kornerup and Wanscher produced a colour atlas[10] based on half-tone printing of 1266 colours with regular progressive admixtures of white and/or black, and this was re-published in England as the *Methuen Handbook of Colour* in 1963. The *Villalobos Colour Atlas* was issued in Argentina in 1947, with over 7000 colour samples produced by half-tone printing from 38 basic chromatic inks selected to cover the whole gamut of the colour circle. The actual sample chips are, however, rather small for most practical uses.

The Japanese have produced a number of colour atlases in the last two decades, one being a very luxurious version of the *Munsell Atlas* with corrected colours according to the theoretical re-allocation propounded by Newhall, Nickerson and Judd in the USA.[11]

In Great Britain there has been great activity in this sphere over the years. The British Standards Institution issued a *Colour Dictionary* in 1934[12] containing 220 samples of silk materials carefully documented, with instrumental readings to establish the intended colours, and this has been followed by many other British Standards with colours for specific purposes and trades. The Royal Horticultural Society[13] issued, in 1966, a very fine range of colours for their own requirements, and this is often quoted in other contexts.

Imperial Chemical Industries issued a very comprehensive atlas entitled *The ICI Colour Atlas* (published by Butterworths, London), containing 1379 colour samples for use in the dyeing industry, and these colours can be modified by the use of transparent overlays, giving a selection of screen printings of grey/black to produce 'shades', so that the final range produced is some 27,580 colours. This was intended as a companion to the *Munsell Atlas*, filling in the intervals between Munsell steps to give very small graduations indeed, such as are required in dyeing. Other well-known atlases are the Ridgeway (USA 1912), and *Maerz & Paul Dictionary of Colour* (USA 1930), and the *Fellowes Atlas*.[14]

The general comment which applies to all colour atlases is that they are suitable only for surface colours (although here they are most useful), that they must be limited as to the number of samples, that they are subject to fading and soiling in use, and that by the range of dyes and pigments available they cannot represent colours of the highest saturation. On the other hand, they are simple to use and it is often an advantage to be able to compare and handle the samples and to be able to transport them into juxtaposition with the object being assessed.

3.4 VISUAL INSTRUMENTS USED FOR COLOUR COMPARISON, CLASSIFICATION, AND/OR MEASUREMENT

3.4.1 Plunger-type instruments, loosely called 'Colorimeters'

These are of the type exemplified by the original Klett and Duboscq instruments, and are used only for coloured liquids. They are chiefly used in chemical estimations for deducing the concentration of a chromophore in solution from

its colour. A solution of known concentration of the same material as the solution under test is placed in a glass tube on one side of the instrument and a clear plunger set to a suitable height in the liquid: the solution of unknown concentration is placed in a similar tube containing a plunger and the light paths from the two plungers are brought together in an eyepiece by means of a prism. The height of the plunger in the test solution is varied until the two sides of the optical field in the eyepiece balance. The concentration of the unknown in relation to the known is then calculated by simple proportion from the heights of the two columns, on the assumption that the Beer/Lambert Laws are followed. This is a quick and simple method where a large number of the same estimations are being carried out regularly and no more sophisticated equipment is available: if the two sides of the visual field are coloured by the same substance, the form of illumination is immaterial, because the match is non-metameric.

3.4.2 The wedge-type 'colorimeter'

This is exemplified by the Pfund colour grader and is used to define the colour of liquids such as honey or oils on a one dimensional scale. The sample is poured into a wedge shaped cell which traverses an aperture, and the colour compared against some fixed agreed standard of the same colour. The distance along the wedge at which the depth being viewed matches the standard is used as the 'measurement' of the colour. This is, of course, a very arbitrary system but is simple and has found use, especially in honey grading and sugar refining.

Under this same heading must be mentioned a whole series of *ad hoc* colour scales which consist of a series of tubes of the same solution but of varying concentration which give a one-dimensional scale of the same hue but varying colour saturation. Representative of these scales are the Iodine Scale and the Gardner Scale, both used chiefly for grading oils and varnishes. (See also p. 115.)

All these above-mentioned one-dimensional scales are for some specific grading test only and are not 'colorimetric' arbiters in the true sense, although frequently referred to in a loose sense as colorimeters.

3.5 VISUAL INSTRUMENTS FOR COLOUR DEFINITION

3.5.1 Visual instruments based on the additive mixture of coloured lights

One may now consider true colorimeters, in the sense that they can match, and define any colour in terms of their own primaries, and this whether it be a surface colour, a transparency, or a light source. The earliest recorded colorimeter of this type is Clerk Maxwell's 'Colour Box', which he described in 1860. This employed the device of inserting adjustable slits in the appropriate parts of a light path leading to a prism unit, so that the emergent beams of red, green and blue lights could be adjusted independently, and the mixture was viewed as a homogeneous colour in an optical viewing unit. The other half of

the field showed the colour of the sample, and the slits were adjusted until a visual match was obtained. The relative aperture areas were then recorded as the amounts of red, green, and blue primaries, which he referred to as x, y and z.

There are three famous colorimeters based on this principle, from which most of our accurate information regarding the properties of normal colour vision have been obtained. These are the Guild (1925)[15] which uses an incandescent lamp light source and three colour filters, the Wright (1927)[16] which uses an elaborate optical system to separate out three wavelengths (460, 530 and 650 nm) from white light as primaries, and the Donaldson (1935)[17] which reverts to the Guild system of filters to obtain the primaries. All are very accurate, and of inestimable value in colour vision research, but are elaborate, costly, and difficult to use. Further, they are not much used for commercial colour control because they produce highly metameric matches, which will obviously vary from observer to observer. The comparison field will be built up from a mixture of three very restricted band-width sources, while the light from most commercial samples is built up from a more or less continuous band from a large part of the spectrum. In 1947 Donaldson[18] dealt with this disadvantage by making his mixture from six primaries. This certainly overcame much of the difficulty of metamerism, and this instrument was used by Stiles and Wysczechi in their exhaustive work on which the revised 1964 CIE Supplementary Standard Observer data was largely based, but for the ordinary mortal the use of such an elaborate instrument for commercial work is not an attractive proposition in terms of the time and skill required.

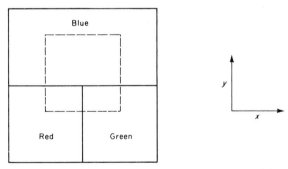

Fig. 3.11. The Burnham colorimeter filter assembly.

A very simple instrument based on the principle of mixing coloured lights is the Burnham colorimeter,[19] used for measuring the colour of transparencies. This uses mirror boxes to mix the light. Such boxes are made with sides of mirror-glass facing inwards and ground glass ends, so that the light is mixed by diffusion and multiple reflections and emerges without much loss. Light from a suitable lamp is fed through a large mirror box so that the emergent light evenly illuminates the exit end. This then enters a second double mirror-box, half of which is covered by the sample to be measured and the other half by a filter assembly in front of an aperture (Fig. 3.11). Horizontal movement of the filters

controls the proportions of red to green light entering the aperture, while keeping the blue component constant. As red plus green light produces a sensation of yellow, it follows that vertical movement of the filters controls the proportion of yellow to blue while keeping the ratio red/green constant. Scales actuated by the two movements give the proportion of the three primary colours in the match. A shutter over the test field allows the luminosity of the two fields to be equalized.

3.5.2 Visual colorimeter based on the subtractive method of producing a match

Under this heading comes the well-known Lovibond Tintometer,[20-23] based on the Lovibond scale of glass colour filters (1870–1880). This scale contains 250 glass slips of each of the three subtractive primaries magenta, yellow and cyan, (wrongly but commonly called, red, yellow and blue), so graduated from the lightest colour perceptible to deeply saturated colours in a strictly arithmetical progression such that, for example, two 1.0 glasses together match a 2.0 glass plus a colourless glass. Equal values of all three together give a grey series down to total absorption, i.e. black. Hence, starting with an agreed white light and interposing suitable Lovibond filters in the light path, nearly 9 million colours of varying brightnesses can be matched. In fact, the whole visible gamut of colour is covered except in the highly saturated green area, and this is now covered by a special procedure (see p. 65). The black to white range is also covered by using the three primaries together. A suitable selection of these glass filters (completely permanent in colour) is mounted in an instrument called a Tintometer in such a way that any combination may be brought into the comparison field of the eyepiece with ease and speed. A light source is built in, equivalent to North Daylight, and either surface colours or transparent samples (including liquids) are viewed in the sample field of the eyepiece in juxtaposition to the comparison field. By changing the combination of glass filters, any colour is easily matched, and the result recorded in terms of so many units each of the three primaries.

Judd and Wyszecki in their book, *Color in Business, Science & Industry*[24] state in regard to the Lovibond Tintometer,

> Although the matches set up are only moderately metameric as a rule, the size of field is 2°. This conforms to the observing conditions of the CIE 1931 standard colorimetric observer, and the calibrations of the Lovibond glasses are, in general, carried out by the maker with such precision that any errors remaining cannot be detected under these observing conditions.

And again quoting

> The Lovibond glasses provide moderately metameric color matches for many commercial products. Because the metamerism is moderate, the problem of one observer's failing to check another is unimportant. So far as is known,

the Lovibond glasses, unless the flashed layer becomes scratched by careless use, are permanent in color. The glasses are convenient to use, either in the Tintometer or in other applications, and the results in Lovibond notation are easy to understand.

As full colorimetric data on all the filters is published,[25, 26] such a formula constitutes an exact and acceptable record of a colour, which can be reproduced immediately anywhere for visual inspection by a simple reassembly of the filters (and there are tens of thousands of these instruments throughout the world), thus getting as near 'measuring' the colour as is possible. With practice, it is possible to memorize the colours of the filters so that a Lovibond formula can be visualized as a mental colour sensation without recourse to reassembling the glass filters.

From the early date of his work, it will be seen that Lovibond was a true pioneer in the field of commercial 'colour measurement'. Starting from a utilitarian *ad hoc* effort to solve a particular problem—the recording of the colour of successive brews of beer—the simplicity and wide usefulness of the system he devised so seized the imagination of the commercial world that Lovibond was forced by popular demand to develop his invention to an extent never envisaged originally by him. After 100 years of use and development, his Tintometer still holds an important place in commercial practice, because of its basic simplicity and flexibility, and because colour is a visual sensation and (in his own words) 'If you want to know what a colour looks like, look at it, and record the result in terms of something that you can see and show to others'. The modern Tintometer (Fig. 3.12) is so designed that every possible type of sample can be measured—emulsions, pastes, sand, soil, and so on, and also very highly textured samples by means of an optical diffusing system, as well as the more orthodox type of surface or clear liquid—so that it is adaptable to tasks not usually thought of as possible for a colorimeter. Modifications have also been introduced, as mentioned in the following paragraphs, to cover specialized applications.

In 1939, Schofield[27] defined the unit value of Lovibond Red, Yellow, and Blue glasses in terms of their internal transmittance values, and from this computed the chromaticity coordinates of every single glass and all possible combinations of pairs, so that these could be expressed in terms of the absolute values of the internationally agreed CIE system (see Chapter 4). He pointed out that the third primary was used in the Lovibond system only to control the brightness level, and that if an independent control of this third dimension were introduced, any sample colour could be matched in colour quality by a combination of glasses from only one, or two, of the Lovibond scales. He therefore devised a means of controlling relative brightness between the two fields of view in a Tintometer (the 'Rothamsted device') so that only two of the three primary scales were ever employed at any one time. This not only simplified the use of the instrument, but made possible the preparation of

Fig. 3.12. Lovibond tintometer (a) and its layout. (b) Top of instrument showing controls; (c) cover removed showing optical system. 1. Viewing tube, 2. Glass colour filters, 3. Lamp housing, 4. Cooling vents, 5. On/off switch, 6. Diffusing screens, 7. Liquid sample compartment, 8. Solid sample position, 9. Detachable leg retaining screws, 10. Instruction plate.

nomograms ('conversion graphs'), from which the CIE colour coordinates of any combination of glasses could be read instantly. Such nomograms are

available for use with four different illuminants, because the colour gamut of any set of transparent filters will vary according to the illumination by which it is viewed (see also p. 65 which deals with a specialized use of this potential). The Lovibond Schofield Tintometer is shown in Fig. 3.13. These nomograms have the advantage, unique to the Lovibond system among colorimeters, that the reverse transformation is possible, so that a CIE coordinate specification can be interpreted in terms of Lovibond numbers, and the required glasses can be superimposed for visual inspection and the actual colour seen—which is what one ultimately wants to do with such specifications.

Fig. 3.13. Lovibond Schofield tintometer (a) and its layout. (b) Top of instrument showing controls. (c) Cover removed showing optical system. 1. Viewing tube, 2. Glass colour filters, 3. Lamp housing and vents, 4. Hours lapse meter, 5. Diffusing screen, 6. Liquid sample compartment, 7. Solid sample position, 8. Detachable leg retaining screws, 9. Brightness control unit, 10. Brightness scale (visual density).

A further development from the Lovibond Schofield Tintometer, still using the principle of employing only two colour scales at a time allied to a separate brightness control, is the Lovibond Flexible Optics Tintometer (Fig. 3.14). This instrument incorporates glass-fibre optic light-guides, so that the controlled

(a)

Standard head

(b)

(c)

Fig. 3.14. Lovibond flexible optics tintometer (a) and its layout. (b) Top of instrument showing controls. (c) Cover removed showing optical system. 1. Viewing tube, 2. Glass colour filters, 3. Lamp housing and cooling fan, 4. On/off switch and indicator, 5. Transformer, 6. Brightness control unit, 7. White reference plate, 8. Flexible viewing leads, 9. Solid viewing head, 10. Sample field filter holder.

illuminant is conveyed direct to the sample (which is external to the instrument) and the resulting modified light is brought back into the sample field of the viewing tube for comparison with the colour of an appropriate selection of colour filters. This obviates having to place the sample in the instrument, and makes possible the colour measurement of large, small or 'difficult shaped' samples, and also of light sources.

Lovibond glasses are also used for the colorimetry of very small samples in conjunction with a Comparison Microscope.

3.6 GENERAL COMMENTS ON THE VISUAL APPRAISAL AND MEASUREMENT OF COLOUR

In order to use any methods of visual colour comparison and/or measurement discussed in the foregoing sections, it is of course necessary to standardize the illuminant used and the geometry of observation so that results may be meaningful. In the case of instruments, this is attended to by the designers, but in the case of the simple methods such as atlases and sample tubes of liquids the user must himself be aware of this need. Further, in all cases of visual colorimetry the observer must be tested for colour vision normality before embarking on such work. As has been stated, about 8% of males and 0.5% of females have abnormal colour vision, and it is obvious that these must be eliminated. There remains a certain 'scatter' of results among observers with normal colour vision, although with training and practice this can usually be reduced to negligible proportions. It is, therefore, advisable to use more than one observer on important work, and to take the mean of the results obtained by them. This is quite usual even where actual measurement is not being attempted, and a panel of assessors is found in many paint and dye works where products have to be passed or failed for colour.

3.7 INSTRUMENTAL MEASUREMENT OF THE FUNDAMENTAL MAKE-UP OF THE COMPONENT PARTS OF A COLOUR

This approach entails wavelength by wavelength measurement of the intensity of the radiation transmitted or reflected by a sample, or emitted by a light source. As has been said, these measurements do not by themselves tell what a colour *looks* like but they provide the basic data from which one can deduce the colour's appearance from agreed conventions.

There is a tendency among some colorimetrists to push refinements of measurements to many places of decimals, thereby giving a false impression of the accuracy to which colour can be 'measured'. It cannot be stated too firmly that colour is a mental sensation—something which one can see—and does not subsist in a string of figures.

3.7.1 Spectrophotometers

The basic instrument for this type of colour measurement is a spectrophotometer, in one form of which white light is split into its component parts by a dispersive element (prism or grating) and by means of narrow slit apertures small areas of the spectrum are isolated in turn and used to illuminate the sample. At each selected wavelength or narrow band of wavelengths, one compares the amount of radiant flux reflected from (or transmitted through) the sample against the flux incident on it (measured against a non-selective reflecting surface such as magnesium oxide or a material such as the synthetic 'G-80 Halon'. (See Figs. 3.15 and 3.16.)

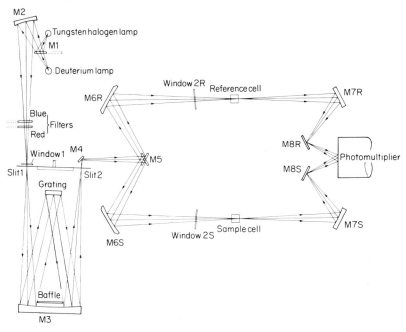

Fig. 3.15. Typical dual beam spectrophotometer layout for measuring transmittance.

In another type of spectrophotometer, the sample is illuminated by the complete selected illuminant and the resulting reflected or transmitted beam is then analysed wavelength by wavelength by means of a monochromator (dispersive element and slit aperture arrangement). This revised order of illuminant, sample, and analyser is especially appropriate when there is any likelihood of fluorescence with the sample. If the monochromator was in the path before the illuminant met the sample, the energy at those wavebands which did not excite the sample to fluorescence would be recorded correctly, while at those wavebands which excited fluorescence there would be recorded a combination of the true reflectance at that wavelength plus all the energy released by the fluorescence, although that would in fact be at other (lower)

wavelengths, and therefore at such points the record would be unduly inflated and not in accord with the facts. If the sample is irradiated by some suitable illuminant and the resulting effect subsequently analysed by the monochromator, the flux will appear at its correct wavelength band, and the result will represent the true visual effect.

Fig. 3.16. A dual beam spectrophotometer layout for measuring reflectance.

The measurement of the colour of fluorescent samples has assumed importance since the introduction of optical bleaches which produce a 'whiter than white' effect, and the use of fluorescent coloured pigments for poster work and certain items of clothing. The 'whiter than white' effect results from the fact that non-visible ultraviolet energy in the illuminant is converted by the fluorescent dyes into radiation in the visible range, so that more energy in the visible range may be reflected than is incident on the sample. If the induced radiation is in the blue region, this will kill any yellowness in the sample and give the impression of improved whiteness.

Another variation in spectrophotometers is the insertion of two monochromators in the optical path in order to minimize the amount of scattered light which might affect the measuring device.

The comparison between the amount of visible radiant flux from the sample and the totally reflecting white surface may be effected by a single or a double beam system, irrespective of where in the optical path the monochromator

comes. With the single beam system, the beam illuminates the sample and the comparison field alternately, while with a double beam the illuminant is split into two beams optically, and both are operative all the time, while an oscillating mirror or a light chopper feeds the light reflected from the sample and the reference field alternately into the recording system. This latter system is used where a continuous graphical record is produced by the instrument.

The recorder, originally the human eye, is now usually a photodetector. The ratios of radiation intensity from sample and standard are usually subsequently plotted, or continuously recorded as a spectral transmittance or reflectance curve (energy against wavelength). In the case of transparent samples, the comparison is between transmitted and incident light flux, and is measured perpendicularly. For reflecting surfaces, the measurement is usually, at 45°, with the illumination at 90°, (or vice versa), so that body colour is measured, and not specular reflection: other angles are sometimes used, however, for special purposes. A dramatic method of illustrating a spectral transmittance curve is shown in Fig. 3.17. This makes it clear that the area under the curve contains all the various wavelengths present in the transmitted or reflected light, and shows the relative amounts of each. The example used is a Lovibond Red glass filter, and it is evident that light from both ends of the spectrum is present in the transmitted light and that there is an absorption in the green area, i.e. the colour seen as a magenta is red plus blue.

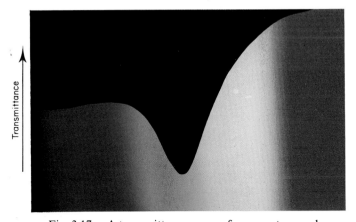

Fig. 3.17. A transmittance curve of a magenta sample.

There are very many versions of this basic set up. The measuring device which compares the two fluxes is usually some kind of photodetector in modern instruments. The figures may be read from a dial one at a time and recorded manually, or recorded automatically as a typed table of figures to be fed directly into a computer for transformation into some selected UCS system, or plotted automatically as a curve of relative energy against wavelength. How these figures are used will be dealt with later. If colour appearance is what is being sought, the figures will be reduced mathematically to coordinates in the CIE

system (see Chapter 4). If chemical analysis is being undertaken, only figures at certain wavelengths are significant, and often only these will be recorded. This is called abridged spectrophotometry. For quickness' sake, abridged methods are sometimes used to judge colour appearance, but unless it is known for certain that two samples being compared are identical in composition (i.e. both base material and dye or pigment) this is a dangerous short cut, as the two may be a pair only at the wavelengths measured, and their spectral distribution curves may differ at some part of the spectrum not measured—in which case it would be possible to deduce from the figures that the samples were identical, while visual inspection would make nonsense of that claim. In the example in Fig. 3.18 the plot from an abridged set of readings (a) could represent either sample (b) or (c), which are in fact different colours visually.

Fig. 3.18. Abridged and full spectrophotometric reading of two samples. The abridged curve (5 readings) in (a) could represent either (b) or (c).

3.7.2 Photoelectric colorimeters

What is equivalent to abridged spectrophotometry, but avoiding the cost of a spectrophotometer and the need for constant skilled maintenance and calibration, is the use of so-called photoelectric colorimeters. These are simpler instruments which isolate selected wave bands by means of colour filters, which may be of glass, gelatine, or of the interference type. These, as with a spectrophotometer, compare the reflected or transmitted flux against the incident flux. For colour appearance measurements, it is essential to use a sufficient number of filters of sufficiently narrow waveband transmission to cover the whole visible spectrum in detail, and the closer the intervals are the more reliable the results will be. (See Fig. 3.19.)

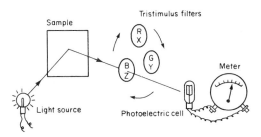

Fig. 3.19. A 3-filter colorimeter.

For reasonable accuracy, probably ten uniformly spaced filters are adequate to give a good picture of the sample. Sometimes as few as three filters are used, but for colour appearance work this can give an entirely misleading indication, unless these three filters are intended to give direct readings in the CIE system of nomenclature (see Chapter 4) and represent the three response curves of the 'standard observer'. To do this is asking almost the impossible, and although many attempts have been made to reproduce such filters, few have been sufficiently close, and none exactly correct so far. However, for routine commercial control work on like samples, some of these colorimeters are adequate, so long as constant calibration and maintenance is carried out. It is important to remember, however, that it is indeed possible for samples to be entirely different colours and yet to agree at several different points in the spectrum, as Fig. 3.20 shows. Such methods are obviously useless with metameric pairs.

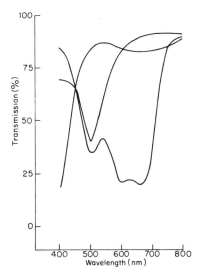

Fig. 3.20. These transmission curves of three filters, a red, a yellow and a blue, show that identical readings are found at several wavelengths.

The Lovibond Automatic Colorimeter (see Fig. 3.21) is an interesting example of combining the advantages of a photoelectric colorimeter, in speed and reproducibility, with the simplicity of a visual system of nomenclature, for easy assessment. This was designed by Unilever Ltd[28] to read the colour of refined edible oils automatically in terms of Lovibond Red and Yellow units, which have been the universal terminology in the oil trade over many decades. The instrument has not been designed for, or calibrated with, crude oil samples. It

Fig. 3.21. Lovibond automatic colorimeter. (a) General view; (b) schematic interior view.

is also less accurate with oils having specific absorption components, e.g. chlorophyll. The instrument accepts oil samples in standard Lovibond sample cells and directly indicates Lovibond Red (R) and Yellow (Y) values. The meters are scaled only to 40 Y/20 R. If the indicated value is off scale, the measurement is repeated with a shorter cell.

The instrument measures the optical density of the sample at two points in the spectrum, approximately equivalent to the peak absorption of the Lovibond R and Y glasses. This function is performed by directing a beam of light having a broad spectrum through a cell containing the sample. The transmitted light is sequentially filtered at the reference blue and green wavelengths by a rotating filter wheel. The filtered light is then detected by a sensitive PIN photodiode whose electrical output is substantially proportional to the intensity of the light falling upon it. The electrical signals are logarithmically amplified and 'stored' as charges on capacitors. To correct for the effect of suspended particles, bubbles etc. a third measurement is made in the red region of the spectrum little affected by the spectral characteristics of the oils. This result is also 'stored', and by appropriate electronic subtraction of this red reading from the previous two values, two voltages are obtained automatically and used to energize two moving-coil meters whose readings are then proportional, in principle, to the logarithm of the relative transmittance of the two test wavelengths with respect to the reference wavelength. From the meters the equivalent Red and Yellow Lovibond values are read off. A dark sample has high attenuation and the measured signals may be so small that the instrument may give an indication which is inaccurate. To avoid this situation, the Yellow signal level is monitored, and if the signal level is too low, the meters are inhibited and the Dark Sample alarm flashes.

In colorimetric chemical analysis procedures, the analyst has to find some reagent which will combine with the element or radical being assayed to form a coloured radical, which colour formation must be unique to the element or must be unique under the particular circumstances of the test, e.g. at a particular pH value. The peak absorption of this coloured solution must then be ascertained, and then it is sufficient to choose a colorimeter using a colour filter of the complementary colour (i.e. with its maximum absorption at that point): the concentration may then be deduced from the recorded transmission by reference to a previously prepared calibration chart.

However, a very elementary precaution is often omitted. It is not unknown for the reagent to be added and the chemical procedure carried out, and the resulting coloured solution blindly measured in the colorimeter without examining it. If some interfering substance is present, the colour may be altered, or the desired colour masked altogether. In some colorimetric chemical reactions, the actual hue of the resulting solution changes with concentration, so a single filter method would be entirely inappropriate in such a case. Before measuring the solution, one must look at it to make sure that the solution is not turbid and is of the expected colour. Total transmission is what a photocell

measures, and if the solution is at all turbid this will give the same answer as a clear coloured solution of much greater density and the answer will be wrong.

In all cases of instrumental colorimetry, except for these specialized cases of chemical analysis, or of comparing like with known like (such as repetitive manufacturing runs of the same material), the figures produced must be interpreted into the visual impression which they would convey to an observer. This procedure is discussed in the next chapter.

It is worth saying most emphatically that automatic methods of measuring colour, however sophisticated, will assist the skilled technician but will not replace him.

REFERENCES

1. D. Nickerson, History of the Munsell Color System, *Color Eng.* **7** (5) (Sept./Oct. 1969).
2. D. Nickerson, History of the Munsell Color System, Company, and Foundation, *Color Res Appl.* **1** (1) Spring (1976).
3. W. Ostwald, *Colour Science* (1st English version), Windsor and Newton Ltd, London, 1931.
4. M. Richter, Das System der DIN Farbenkarte, *Farbe* **1**, 85 (1953).
5. W. Budde, H. E. Kundte and G. Wyszecki, Uberfürung der Farbmasszahlen nach dem Farbsystem DIN 6164 in Munsell-Masszahlen Ungekehrt, *Farbe* **4**, 83 (1955).
6. Anders Hård, *A new colour atlas based on the Natural Colour System by Hering–Johannson*, Fackskrift Nr 2 Svensk Färgcentrum, Stockholm, DK 535, 653, 87 (1968).
7. Anders Hård, The Natural Colour System, *Proc. Internat Colour Assn. at Stockholm*, Vol. 1, Musterschmidt, Gottingen, 1970, p. 351.
8. D. B. Judd and D. Nickerson, Uniform perceptual scales of color: relation between Munsell and Swedish NCS scale, *J. Opt. Soc. Am.* **63**, 1280A (1973).
9. D. B. Judd and D. Nickerson, Uniform perceptual scales of color: relation between Munsell and Swedish NCS scale, *J. Opt. Soc. Am.* **65**, 85 (1975).
10. A. Kornerup and J. Wanscher, *Farver i Farver*, Politikens Forlag, København, 1961.
11. S. M. Newhall, D. Nickerson and D. B. Judd, Final Report of the USA Sub-committee on spacing of Munsell colors, *J. Opt. Soc. Am.* **33**, 385 (1943).
12. *The British Colour Council Dictionary of Colour Standards*, British Colour Council, London, 1934. (Adopted as British Standard BS543.)
13. *The Royal Horticultural Society Colour Chart*, London, 1966.
14. E. Fellowes, *Colour charted and catalogued*, Geographia, London.
15. J. Guild, A trichromatic colorimeter suitable for standardisation work, *Trans. Opt. Soc. (London)* **27**, 106 (1925).
16. W. D. Wright, A trichromatic colorimeter with spectral stimuli, *Trans. Opt. Soc. (London)* **29**, 225 (1927).
17. R. Donaldson, A trichromatic colorimeter, *Proc. Phys. Soc. (London)* **47**, 1068 (1935).
18. R. Donaldson, A colorimeter with six matching stimuli, *Proc. Phys. Soc. (London)* **59**, 554 (1947).
19. R. W. Burnham, A colorimeter for research in color perception, *Am. J. Physiol.* **65**, 603 (1952).
20. J. W. Lovibond, The Tintometer, a new instrument for the analysis . . . and measurement of colour. *J. Soc. Dyers Colour.* **111** (2) 26 Dec. (1887).
21. F. W. Edridge Green, The scientific value of Lovibond's Tintometer, *J. Soc. Arts* **40**, 213 (1891/2).

22. G. S. Fawcett, Sixty years of colorimetry, *Proc. Phys Soc.* **56**, 8 (1944).
23. G. J. Chamberlin, Seventy years of colorimetry, *Proc. Am. Assoc. Textile Chemists: Am. Dyest. Rep.* **3**, 18 Jan. (1955).
24. Deane B. Judd and G. Wyszecki, *Color in Business, Science & Industry*, 3rd Edn, Wiley-Interscience, 1975, pp. 200, 201.
25. D. B. Judd, G. J. Chamberlin and G. W. Haupt, The ideal Lovibond system, *J. Res. Natl. Bur. Stand. Sect. C* **66**, 121 (1962).
26. M. S. Carrie and G. M. Keeley, The CIE specifications of some ideal Lovibond glasses and their combinations illuminated by Source C, *N.Z. J. Sci.* **10**, 585 (1967).
27. R. K. Schofield, The Lovibond Tintometer adapted . . . to the CIE system, *J. Sci. Inst.* **XVI**, 74 (1939).
28. D. M. Ffinch and S. J. Poke, An evaluation of the Unilever Automatic Colorimeter as an alternative instrument for the determination of the colour of oils and fats, *Technical Circular 634*, British Food Manufacturing Industries Research Assn, Leatherhead, February 1977.

INTERPRETATION OF COLOUR MEASUREMENTS

4.1 ILLUMINATION

As has been said, colour cannot be measured as one measures length or weight. Some way must be found to describe the sensation of colour in a way which will correlate with the visual image.

The natural approach to describe a colour is a visual one. As has been truly said, 'If you want to know what a colour looks like, look at it and describe what you see'. But the colour of an object changes according to the illumination by which it is viewed, so one must start by agreeing on a suitable illuminant. Human eyes have evolved for use in daylight, in the wavelength band between roughly 400 and 700 nm—a very small section of the total range of the electromagnetic spectrum, which ranges from cosmic rays at 5×10^{-5} nm through infrared energy to the long waves of radio up to 1×10^{12} nm. Note, however, that the energy distribution in this small visual band is not uniform, as is shown in Fig. 4.1.

Furthermore, human eyes are not equally sensitive to energy of all wavelengths in the visual spectrum, as is shown by the 'relative spectral sensitivity' or V_λ or 'equal energy luminosity curve' (Fig. 4.2), which shows the relative response of the cone vision of a normal observer to light of different wavelengths. The response of the rod vision at low (scotopic) levels of illumination is different, but consideration of this is omitted here, as colorimetry can only be performed at higher (photopic) levels, when cone vision is dominant.

Hence the visual response to light is a compound of what is in the light and how the eyes react, and the visual colour of an object is the light as modified by the object and again modified by the visual response to the illuminant. Some artificial illuminants which are due to incandescence, such as tungsten lamps, gas lamps, or candle light, similarly have a continuous spectrum of wavelengths (although with a different energy distribution to daylight) and thus allow an object to reflect an approximation of its 'normal' colour, and by the brain's

Fig. 4.1. Average spectral energy distribution curve for totally overcast sky of colour temperature 6500 K.

power of adaptation one can discount the slight distortion, and identify the true colour.

If the spectral power distribution of an illuminant has gaps, it may mean that the wavelengths at which an object can most strongly reflect are missing, and under these conditions the colour is badly distorted. For example, a fluorescent lamp may be deficient in the red end of the spectrum (Fig. 4.3), and a red object would then appear brown or grey when illuminated by a badly adjusted fluorescent coating to a lamp.

For these reasons, it has been agreed that diffused daylight (not direct sunlight) is the appropriate illuminant to use when comparing and recording colours. Although even the quality of this light varies during the day, the eye

Fig. 4.2. Relative spectral sensitivity of the human eye for photopic vision.

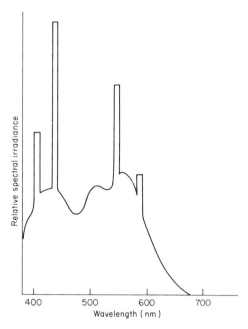

Fig. 4.3. Relative spectral power distribution for a typical daylight fluorescent lamp (6500 K).

plus brain can normally compensate, so long as there is enough light for good discrimination. For precise instrumental work, an artificially produced average daylight (the result of an incandescent source, 'Illuminant A', a tungsten lamp at a colour temperature of 2856 K plus appropriate colour filter: Fig. 4.4) is used by general agreement.[1]

4.2 VIEWING GEOMETRY

As well as defining the illuminant, agreement must be reached on the geometry of how one views a coloured object, i.e. area of field of view, angle of illumination and angle of viewing, before standardized conditions are established. As previously mentioned, the rod-free area of the retina is a very small central patch, and from there outwards the concentration of cones decreases and rod vision increasingly intrudes. Nevertheless, all eyes are not the same in terms of this distribution, so that the bigger the area of the retina on which the image falls, the greater the possibility of variation between observers. Now an area which subtends an angle of up to 4° on the centre of the retina (the fovea) provides an image which falls on a virtually rod-free patch, so it is a convention that comparisons of colour between different observers are most reliable when only this size field is used. This area is approximately equal to the size of one's thumbnail as viewed at arm's length. The larger the field viewed,

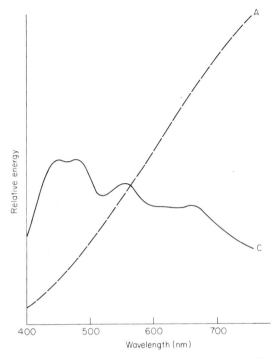

Fig. 4.4. The dashed curve shows the relative spectral power distribution of CIE Illuminant A, while the solid line shows this energy distribution modified by a glass filter to give CIE Illuminant C.

the more the opportunity for disagreement, although individual observers may choose larger fields for their personal judgement. Beyond a certain size, the eye cannot take it all in at a glance, and the area is scanned, so that sections of the image at a time pass over the fovea. As regards angles of illumination and viewing, texture can alter colour as the angle changes, so a convention has been agreed that the light should be falling at 45° and the sample viewed perpendicularly; or vice versa if preferred.

4.3 BACKGROUND

Yet another condition remains to be standardized—that of background. All colour judgement is relative to other colours in the field of view, and therefore this source of error must be controlled. Red seen against a green background appears redder by contrast, and so on. Therefore, an achromatic background is needed—black, white or grey—and this must be agreed. If the sample is sufficiently large it will constitute both background and point of fixation.

Finally, it is clear that observers comparing results must have normal colour vision. As about 92% males are so graded, and a much higher percentage of females, this is not a great obstacle.

4.4 RECORDING COLOUR DATA

Having agreed on illuminant, background, conditions of observation, and an acceptable observer, one can proceed to compare and, if required, to record colour by any chosen visual method. Where instruments are employed, the design of the instrument should have taken care of the first three conditions.

Increasingly, however, automatic methods with a spectrophotometer or a filter colorimeter, employing photoelectric detectors in place of an observer, are used. This substitution of a photodetector for an observer in measuring the relative luminosity transmitted by or reflected from the sample at various wavelengths, as compared with the incident light, makes the measurement objective instead of subjective; but it must be remembered that such detectors are not perfect. They are as likely as a real observer to give erroneous results unless they are carefully used by an operator who understands their character and can quickly spot any deviation or malfunctioning, and who knows how to service them correctly. They can be affected by fatigue, temperature changes, excessive humidity or even pollution of the surrounding atmosphere by solvents, so that constant vigilance is necessary. They do, however, greatly speed up operations and can be connected to recorders or computers to mechanize the whole operation, although the figures may be recorded manually in less costly instruments. In essence, a spectrophotometer contains an optical dispersion system of prism or grating, and diaphragms which allow the sample to be illuminated with discrete wavebands one at a time, and a detector which records the luminosity reflected or transmitted compared to the incident light. The smaller the waveband used, the greater the accuracy of the results, but this increases the complexity and the cost of the apparatus. The result gives a clear definition of how the colour is built up from its component parts, but does not say what the colour looks like (except in a general way in the case of very simple colours with only one area of maximum transmission or reflectance), any more than a chemical analysis can describe the taste of a substance. Only colours with identical readings throughout the visible spectrum can be said to be a true colour match. The figures as they stand may be used when the colour of a chemical solution is being used as a means of quantitative chemical analysis, but if a colour is being examined to say 'what it looks like', the figures must be related to a visual sensation. To do this, the Colorimetry Committee of the Commission Internationale de L'Eclairage has evolved a convention which takes account of all the parameters mentioned in regard to visual colorimetry: see CIE publication No. 15 (1971),[2] to which Supplements 1 (Special Index of Metamerism), 2 (Colour Difference Formulae) and 3 (Lightness Scale) have subsequently been added.

4.5 THE CIE SYSTEM

The first international agreement on the mathematical treatment of colour data, so that there may be a common basis for calculations, came at the 1931

Commission Internationale de L'Eclairage Conference held in Cambridge, UK. Since then various additions and modifications have been made, culminating in the issue of the recommendations of Committee 1.3.1 in 1971. This serves as a method to reconcile various types of approach to colour measurement, and measurements by all acceptable methods can be expressed in a common form which is above language differences.

The system starts from the Maxwell triangle illustrating the mixture of coloured lights. This was shown in Fig. 3.4 in outline, and is developed as a demonstration in mixing coloured lights in Fig. 4.5. Along the sides will be found mixtures of two only of the three primaries, in every possible proportion, so that each primary merges imperceptibly into the next: as the third primary is assumed to be at zero intensity on the line opposite, the colours on the sides are at maximum saturation for the primaries involved. As one travels from a side towards the centre, the third primary comes increasingly into play, and dilutes the colour, so that at the centre (if the primaries have been correctly balanced) a true white is seen. On any line drawn from the centre to the perimeter of the triangle, the proportions of the two primaries forming that side remain constant and the third decreases, so that the colour quality represented diagrammatically is of constant hue but increasing saturation. If one now defines exactly the three coloured lights in terms of wavelength, and in an instrument adjusts the luminance of the three lights to produce white at the centre, one can reproduce any hue (but not all saturations, as explained later), and define the colour by its coordinates by pin-pointing its position in the triangle.

Fig. 4.5. A Maxwell triangle demonstration.

If, however, such a set-up is used to match the colours of the spectrum wavelength by wavelength, it is found that mixtures of the primaries, although the most saturated obtainable, are unable to match in saturation the intermediate colours, while matching perfectly as regards hue. In other words, the path of the spectral colours falls outside the triangle except at the three fixed points, as shown in Fig. 4.6.

To match these other spectral colours they must be desaturated by being mixed with an appropriate amount of the third primary to bring them in towards the centre. Hence 'unreal' primaries X, Y and Z were adopted, which formed a triangle enclosing the whole of the spectrum locus without having to adopt the rather clumsy device of using negative values when the sample has to be desaturated before matching. (See Fig. 4.7.)

By choosing such imaginary primaries (defined in terms of mixtures of real lights) it was possible to adjust them to satisfy other requirements for simpler calculations. It was found experimentally that the relative luminosities of the three chosen real primaries when adjusted to match an 'equal energy' white were red 1.0, green 4.5907, blue 0.0601, and the decision was taken to plot the triangle so that all the luminosity should be attributed to Y and that X and Z have colouring power but no luminosity. Y is analogous to an imaginary super-saturated green, X to a super-saturated red, and Z to an unattainable blue. Therefore, in any expression of a colour in terms of X, Y and Z, the Y value carries not only the green component but also the luminosity value. Based on the Standard Observer data, and using real red, green and blue primary stimuli with units adjusted such that equal quantities are required to match white, the definition adopted was (when R is 700 nm, G is 546.1 nm, and B is 435.8 nm)

$$1.0\,X = \quad 2.3646\,R - 0.5151\,G + 0.0052\,B$$
$$1.0\,Y = -0.8965\,R + 1.4264\,G - 0.0144\,B$$
$$1.0\,Z = -0.4681\,R + 0.0887\,G + 1.0092\,B$$

$$1.0000\,R \quad 1.0000\,G \quad 1.0000\,B$$

Note, that equal quantities of both stimuli $X\,Y\,Z$ and $R\,G\,B$ are required to match white.

Having thus defined an area in which all colour qualities find a place, how does one handle the mathematics? Tristimulus values X, Y, Z represent quantities and can be reduced to relative proportions, or chromaticity coordinates (designated x, y, z) thus:

$$x = \frac{X}{X+Y+Z} \qquad y = \frac{Y}{X+Y+Z} \qquad z = \frac{Z}{X+Y+Z}$$

The two coordinates x and y can be used as the axes of a rectangular graph to derive the CIE Chromaticity Diagram (Fig. 4.8). The curved line is known as the spectrum locus and represents the series of points on which all pure spectral

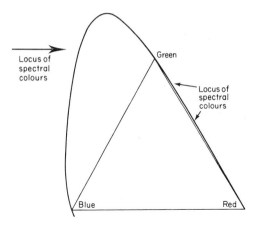

Fig. 4.6. Locus of spectral colours.

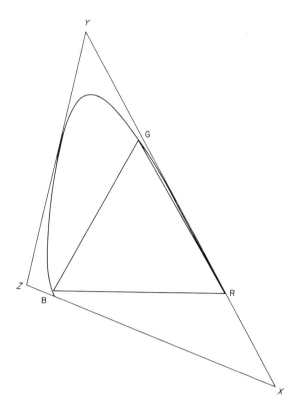

Fig. 4.7. *XYZ* triangle.

colours will lie. A number of everyday samples are shown plotted in their respective positions. Now we have a kind of colour map, which is however subject to severe aberrations, due to non-uniformity of visual response over the area. The CIE definition of a Chromaticity Diagram is a diagram in which distances along suitable axes represent chromaticity coordinates.

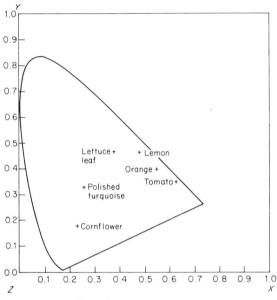

Fig. 4.8. CIE diagram.

It must also be remembered that such a diagram is two dimensional, dealing only with hue and saturation, and it does not take into account brightness value, so that the same spot represents every possible brightness value. For example, the centre achromatic point is not white only, but every brightness value down to zero or black.

At this point, the response of a 'normal' eye, that of the 'Standard Observer', must be taken into consideration if the final mathematical expression is to be in some way related to the visual image presented by a colour. This hypothetical person is the mean of seven real observers tested by Guild (1931)[3] at the National Physical Laboratory, Teddington, and ten real observers tested by Wright (1929)[4] of the University of London (later supplemented by 35 observers). These observers were required to match the spectrum at very narrow intervals using three real primaries, and their results were transformed into the XYZ system. These tristimulus values, standard observer weighting functions, or Distribution Coefficients (Fig. 4.9) are designated $\bar{x}\,\bar{y}\,\bar{z}$ (pronounced x bar, etc.) published as tables which in effect define how the 'standard observer' sees any given colour. As he is such an important ingredient in the CIE system, we asked our artist to draw his portrait, and this fantasy cartoon is his reply (Fig. 4.10).

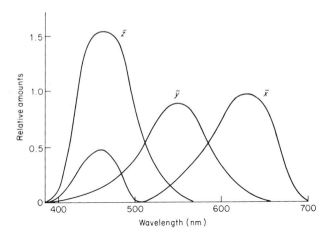

Fig. 4.9. Distribution coefficients $\bar{x}\,\bar{y}\,\bar{z}$ plotted energy against wavelength.

Fig. 4.10. The standard observer: his portrait.

As previously explained, the illuminant employed greatly influences the colour seen. Consequently, the CIE has published tables giving the spectral

energy distributions (Relative Spectral Power) of four selected permissible illuminants. These illuminants were originally:

A — representative of an incandescent lamp operated at a colour temperature of 2856 K.
B — representative of noon sunlight, obtained by a lamp as A plus a defined colour filter, and designated as a colour temperature of 4874 K.
C — representative of average daylight as from an overcast sky, obtained by a lamp as A plus a defined colour filter, and designated as a colour temperature of 6774 K.

However, dissatisfaction arose over the C reproduction of daylight because of deficiencies in the blue and ultraviolet range, and it was decided to undertake a series of major studies to determine the colour and the spectral power distribution of daylight in various geographical locations. The first of these to be published was a series of visual determinations over a period of twelve months by Chamberlin et al.,[5] and this was followed by a study by Nayatani and Wyszecki using a Donaldson 6-stimulus colorimeter.[6] Spectrophotometric studies were made by many workers, including Henderson and Hodgkiss,[7] Judd et al.,[8] and Tarrant,[9] and from all these results was deduced an acceptable average which was adopted in the 1971 CIE Publication No. 15 under the name of D_{65}. This amended the shortcomings of Illuminant C as regards the blue and ultraviolet end of the spectrum, and has a chromaticity analogous to a colour temperature of 6500 K. It is an unfortunate fact, however, that no guidance was given as to how such an illuminant is to be realized in practice, and to date no actual illuminant has been produced which exactly reproduces D_{65}. Computers can therefore define colours illuminated by this theoretical D_{65}, but no one has yet seen such colours in actual fact, and therefore Illuminant C is still largely used in commerce, especially in view of the vast number of records already in existence in terms of Illuminant C.

In CIE Publication 15, figures are also given for other illuminants in this D series, e.g. D_{55} and D_{75} (corresponding to correlated colour temperatures 5500 K and 7500 K), but these are only used for specialist purposes.

All the various threads in the pattern have now been mentioned. If the figures are integrated for the illuminant used, for the response of the Standard Observer, and the reflectance or transmittance figures for the actual sample under consideration, the final result gives a position which can be plotted on the colour triangle, which represents the actual point at which the colour would be found— and this is an absolute value independent of all other considerations. If the illuminant were changed, the perceived colour would change, and so would the position on the chart. However, it must be emphasized that all that has been achieved is to say that a mixture of the defined stimuli would at that point produce a sensation equivalent to the sensation produced by the colour sample. One cannot measure the sensation itself.

All this calculation is too laborious for routine handling by an operator, and is today normally handled by a computer. Tables are published, (see Wright,[10] Judd,[11] or Wyszecki and Stiles[12]), which integrate the figures for the relative energy E of the illuminant used, with the distribution coefficients $\bar{x}\,\bar{y}\,\bar{z}$, and these are combined with the spectral reflectance or transmittance data of the sample to give tristimulus values X, Y, Z, and chromaticity coordinates x and y as explained in Chapter 5.

One specialized form of table has long been used to simplify this calculation and is known as the Selected Ordinate method. By sampling the spectrum at specially chosen points, the recorded figures need only to be added and multiplied by a factor. The need for such short cuts has largely disappeared.

Although most colorimetric work is based on the 1931 Standard Observer tables of Guild and Wright, which used a 2° field of observation, the CIE 1971 report also includes tables for a 10° field from the work of Stiles and Burch, and Speranskaya. This, however, has been the subject of much discussion and criticism on the theoretical grounds of non-additivity of light mixtures under these conditions, and this approach has also to battle against the prejudiced inertia caused by many years of experience and records accumulated using the Guild and Wright data.

It was mentioned previously that, as a map of colour quality, the colour triangle so far considered is subject to severe aberrations. This is because the eye is not equally sensitive to all colours, and can easily distinguish very small differences in some areas while being relatively insensitive in others. This is shown diagrammatically in Fig. 4.11, due to Wright. The lengths of the lines

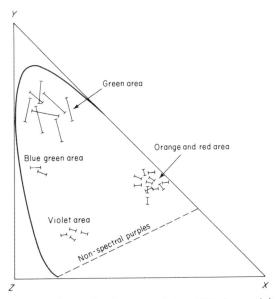

Fig. 4.11. Subjectively equal colour steps in the CIE chromaticity diagram.

indicate the relative distances across the chart which one has to travel to perceive a distinctly different colour sensation, and these are manifestly not uniform in different areas. Lines pointing towards the centre indicate changes in saturation, while lines following the spectral locus indicate changes in hue, and the eye is more sensitive to the latter.

In Fig. 4.12 it is clearly shown that in this representation of the CIE diagram an undue proportion is given to the green area. Very many transformations have been suggested to correct this distortion and to represent at all parts of the diagram approximately equal perceptual steps for colours of the same luminance, one of the first being due to Judd in 1935,[13] and how in principle this was

Fig. 4.12. An artist's impression of the CIE 1931 chromaticity diagram.

achieved was illustrated, in a book in 1951 by one of us,[14] in a cartoon (Fig. 4.13) which has since been copied by many other authors.

Fig. 4.13. Judd's transformation of the 1931 CIE diagram.

This method is based on the use of an equilateral triangular plot, and the complication of plotting on triangulated graph paper led to the more general adoption of the simpler rectangular systems of Breckenridge and Schaub (1939)[15] (this being known as the Rectangular Uniform Chromaticity Scale system), and Farnsworth (1944),[16] but none are perfect because uniform chromaticity steps cannot be represented in a plane diagram. It would have to be a 3-dimensional figure with irregular contours, and therefore all transformations must be approximations, and it is for the user to choose which he prefers. In the nomogram which the Tintometer company has issued to transform Lovibond Unit values to CIE coordinates,[17] the Judd system was adopted, and has proved satisfactory. In the CIE 1960 recommendations, the

method of MacAdam (1937)[18] was adopted, and the transformation into the new coordinates u, v, w, of the CIE Uniform Colour Scale was given as:

$$u = \frac{4x}{-2x + 12y + 3}$$

$$v = \frac{6y}{-2x + 12y + 3}$$

$$w = \frac{3y - 3x + 1.5}{6y - x + 1.5}$$

This 1960 formula applied to the CIE Standard Observer Data produces a spectrum locus as illustrated in Fig. 4.14. It will be seen from this diagram that all yellow, brown, orange, and red colours are crushed into a relatively small area of the triangle between the achromatic point and the spectrum locus, yet this area should be as large as possible because of the importance of these colours in the food, oil, paint, and other industries, where numerous one-dimensional colour scales are in common use for colour grading.

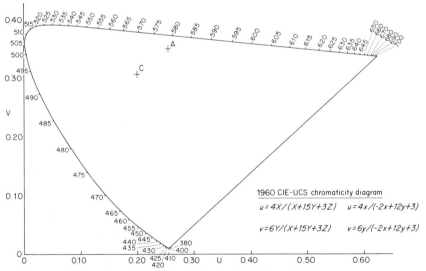

Fig. 4.14. The 1960 transformation of the CIE diagram.

In 1976, therefore, this formula was revised[19] to expand this area as follows (Fig. 4.15):

u' (1976) now equals u

v' (1976) now equals $\dfrac{3v}{2}$

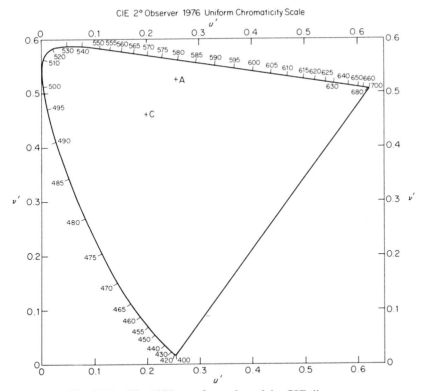

Fig. 4.15. The 1976 transformation of the CIE diagram.

With experience and practice it is possible to visualize approximately the colour of a sample from its position in the chart. The result of additive colour mixtures can be deduced on such a chart by the use of weighted average (or centre of gravity) calculations, but subtractive mixtures are subject to so many complications that they cannot be so calculated, and must be found from experimental checks.

Another method of expressing the visual aspect of a colour is to use the Saturation Purity procedure. Any colour quality can be matched visually by a mixture of a spectral light of the correct wavelength, suitably diluted by white light to produce the appropriate saturation level. In the chromaticity diagram, a line joining the achromatic point to the spectrum locus always remains on the same wavelength (hue) but traverses every possible saturation from white (0% saturation) to the spectral colour (100% saturation). Hence, if the coordinate point of the sample be plotted on a CIE diagram, and a line drawn from the achromatic point through this position and continued to the spectrum locus, it will cut the locus at the wavelength of the colour, and the percentage distance out from the achromatic point gives the percentage saturation of that colour. This is an unequivocal way of pin-pointing a colour which can also be used with

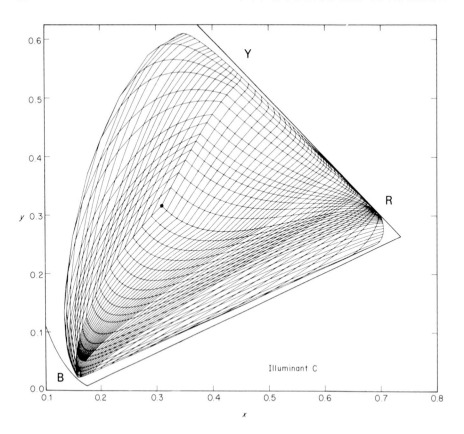

Fig. 4.16. Chromaticity diagram for ideal Lovibond colour system showing the relationship between the CIE 1931 (x, y) system and single-colour units and two-colour combinations of red, yellow, and blue for CIE standard Illuminant C.

experience to visualize a colour from a set of figures. It is particularly useful in the dyeing industry, where differences in saturation are more acceptable than differences in hue, and this procedure highlights hue differences. This method of using the coordinate figures plotted on the CIE chromaticity diagram is also called the Dominant Hue Wavelength method.

A further step from uniform chromaticity scales to represent colour (or chromatic) quality is to develop a uniform colour solid which also takes into account brightness (luminance factor). Such a colour solid was recommended for use by the CIE in 1964, and this is incorporated in the 1971 CIE comprehensive publication 15. This is the CIE $U^* V^* W^*$ system, for which transformation formulae are published, and this solid approaches very closely to the Munsell colour solid. An interesting exercise was carried out in 1972 by the US Bureau of Standards, in which they produced comparison diagrams (Figs 4.16–4.19) of the Lovibond glasses using the 1931 CIE (x, y) system, the

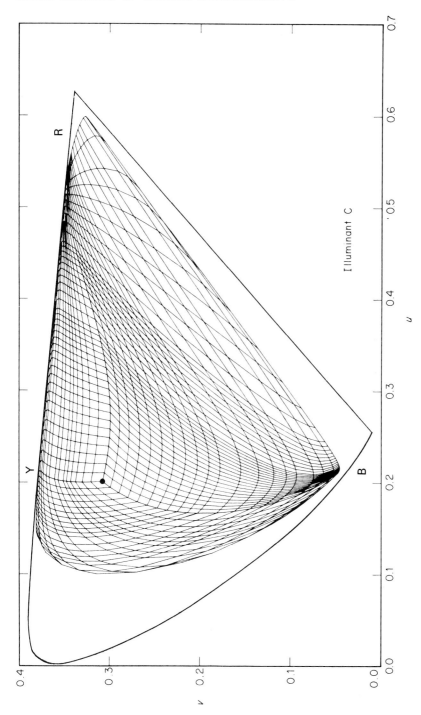

Fig. 4.17. Chromaticity diagram for the ideal Lovibond colour system showing the relationship between the CIE 1960 (u, v) system and single-colour units and two-colour combinations of red, yellow and blue for CIE standard Illuminant C.

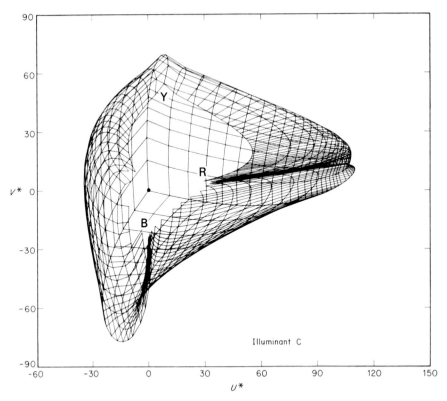

Fig. 4.18. Chromaticness-index diagram for ideal Lovibond colour system showing the relationship between the CIE 1964 (U^*V^*) system and single colour units of red, yellow and blue and two-colour combinations for CIE standard Illuminant C.

1960 CIE Uniform Chromaticity (u, v) system, and the 1964 ($U^* V^* W^*$) CIE system, by which they brought out clearly what information can be learned from the use of these different systems.[20]

In 1976 it was agreed by various international bodies to adopt a colour space, $L^* a^* b^*$, proposed by workers whose main interest lay with surface colours.[21] The CIE Committee then suggested modifying the existing $U^* V^* W^*$ formula so that both systems should have a common brightness scale. Since 1976 therefore, the CIE Colorimetry Committee officially recommends two colour spaces, with their associated colour difference formulae. One is usually known as the CIELUV and the other as the CIELAB colour space.

The $L^* u^* v^*$ system therefore supersedes the older $U^* V^* W^*$ space adopted in 1964, and both the $L^* u^* v^*$ and the $L^* a^* b^*$ systems are jointly recommended for further study. No data comparable to the Bureau of Standards Paper of 1972 mentioned above have yet been published to aid in the comprehension of these new systems.

One very interesting point is often overlooked in connection with the

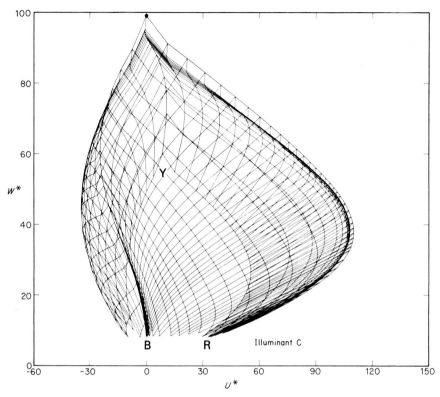

Fig. 4.19. Chromaticness-index–lightness-index diagram for ideal Lovibond colour system showing the relationship between the CIE 1964 (U^*V^*) system and single colour units of red, yellow, blue and two-colour combinations for CIE Illuminant C.

application of subtractive colour matching by means of colour filters. A colour filter only has a defined chromaticity when considered in conjunction with a stated light source. This gives the system a seldom appreciated but startling flexibility: specific areas of the colour diagram can be matched and plotted in magnified detail by the suitable choice of illuminant. Thus, the highly saturated green area of the chromaticity diagram is of great interest to television and signals engineers, but it is difficult to match under daylight conditions because blue primary filters often have a transmission in the red area. The Tintometer Company has used this possibility of shifting the gamut of any set of filters[22] (in their case the Lovibond scale of glass filters) by using a cyan illuminant in the matching field, and thereby shifting the whole matching gamut almost into the extreme green limit of the CIE chromaticity diagram as illustrated in Figs 4.20 and 4.21. A special nomogram is then used, computed on this new illuminant, to bring the answers back into the standard x, y, z coordinate nomenclature, or the u' v' (1976) system if required.

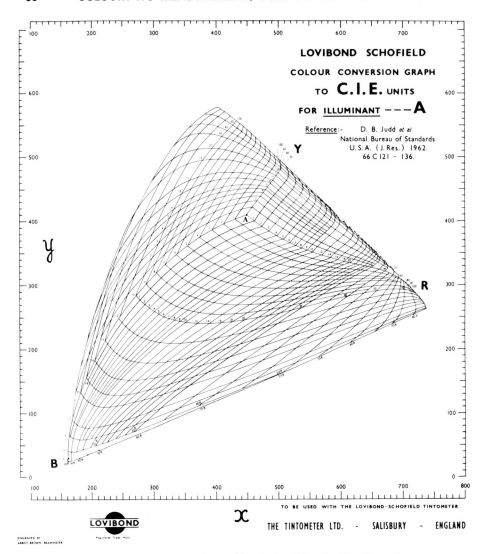

Fig. 4.20. Coverage of the Lovibond glass filters in Illuminant A.

The need behind this search for a uniform way in which to represent colour is to allow tolerances to be laid down in industrial work. Specifications have to be agreed to, as between buyer and seller, for the latitude which can be tolerated in the closeness of reproduction of the colour of a product over long periods, or for the copying of a colour from some original. This is referred to as the number of least perceptible differences (LPDs) or just noticeable differences (JNDs).

The question arises as to what is a JND. MacAdam in 1943[23] investigated this matter and propounded the suggestion that ideally a circular area should be agreed, on a uniform chromaticity diagram, to define a JND and he laid down

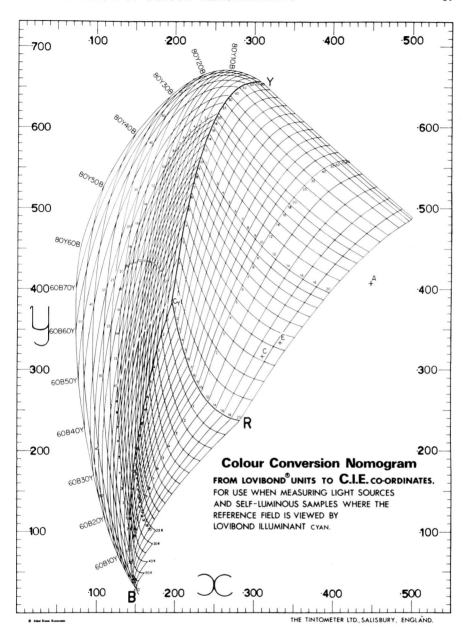

Fig. 4.21. Coverage of the same filters when viewed in 'Illuminant Cyan'.

such a definition. However, because of the non-uniformity of all such diagrams, all these areas turn out to be ellipses (Fig. 4.22) which vary in size over the different parts of the diagram, and the search has been on ever since to find a

diagram which will reduce these MacAdam ellipses to uniform circles. The first one adopted was the CIE uv diagram, but the MacAdam discrimination plots were still differing sizes of ellipses.

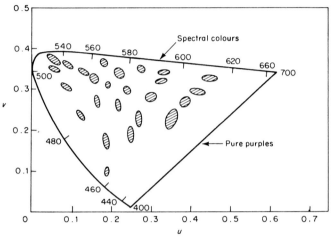

Fig. 4.22. The MacAdam discrimination ellipses plotted on the CIE (u, v) uniform chromaticity diagram. These are shown ten times the actual size, but with their centres correctly positioned.

Formulae are available by which it is possible to calculate differences in colour quality in terms of this MacAdam concept.

Another way to express agreed tolerances is in terms of the Munsell notation, and the makers of Munsell charts perform a very valuable service in this respect by offering 'tailor-made' physical samples showing the agreed variation for a given colour in each possible direction. Two tolerances are necessary for each parameter, one in the plus and one in the minus direction. These limits are called H + and H − (Hue), V + and V − (Value) and C + and C − (Chroma) for the three attributes of colour. The colour chips are arranged as shown in Fig. 4.23, with apertures at suitable locations. The necessary judgement is made with the sample showing through the aperture.

4.6 MIX PREDICTION

Closely connected with this problem of laying down tolerances is the matter of formulating mixtures of dyes and pigments to match a given sample. Theoretically it is possible to program a computer with the spectrophotometric figures for a wide range of ingredients and then ask it to select the appropriate mixtures to match a given sample whose energy distribution figures are supplied. Spectrophotometers are not in sufficiently close agreement, however, for such an exercise, and it has transpired that it is unusual for the figures from one instrument to be sufficiently in accord with those from another for the predicted formulae to produce a better match than could be obtained by more laborious

Fig. 4.23. Munsell colour tolerance set.

traditional methods. If the sample and the available ingredients are matched on the same instrument carefully enough, however, valuable time can be saved by mix prediction as compared to trial and error methods. The reliability of a predicted match formula depends on the accuracy of the specifications supplied by the customer for his sample, and of course the accuracy also of the maker's measurements of the available ingredients.

The differences between instruments used for 'measuring' colours have been mentioned, and where figures are published for use by more than one user, it is clearly important to have some way of comparing the performance of different operators, instruments, and laboratories, so as to be able to introduce some standardization and order into the subject. From time to time various societies and scientific bodies have circulated samples (usually solutions of stated chemical composition) in an endeavour to achieve this end: the results have often been lamentable in their discrepancies, and it has been easy to blame deterioration in the solutions or inaccuracy in the preparation of the sample in different laboratories.

An important attempt was made by the British Ceramic Research Association, who in 1968 prepared a large number of duplicate sets of ceramic tiles which were most carefully processed and individually checked for colour (which is of course permanent) and which covered a wide range over the chromaticity diagram. A representative set was examined and reported by the National Physical Laboratory, Teddington,[24, 25] and duplicate sets were made available for sale, accompanied if required by a full set of spectrophotometric data and

chromaticity coordinates certified by the NPL for each specific set. This has proved a valuable and salutary weapon, and in the report by Malkin[26] on an analysis of the results reported by a large selection of laboratories, it emerged that while the consensus was on the whole not discouraging, the confidence placed by some workers in their results was misplaced and called for reappraisement. The dictum of W. D. Wright of some years ago that 'Colorimetry is a valuable tool, which has however not so sharp an edge as we could wish it to have', was shown still to be true.

The work of many researchers is constantly aiming at achieving that sharpening, and this includes the various industrial and national standardizing laboratories, and also the combined efforts of many national bodies concerned with the science of colour, and international bodies, such as the CIE and the Association Internationale de la Couleur.

REFERENCES

1. R. Davis and K. S. Gibson, Filters for the reproduction of sunlight and daylight etc., *Bur. Stand. Misc. Publ.* **114**, 129 (1931).
2. Commission Internationale de L'Eclairage Publication No. 15, *Colorimetry* by Committee 1.3.1, Bureau Central de la CIE, 4 Ave du Recteur Poincaré 75, Paris 16me.
3. J. Guild, The colorimetric properties of the spectrum. *Phil Trans. R. Soc. London Ser. A* **230**, 149 (1931).
4. W. D. Wright, A redetermination of the trichromatic coefficients of the spectral colours, *Trans. Opt. Soc. (London)* **30**, 141 (1928).
5. G. J. Chamberlin, A. Lawrence and A. A. Belbin, Observations on the related colour temperature of north daylight in Southern England, *Light Light.*, 70 (March 1963).
6. Y. Nayatani and G. Wyszecki, Color of daylight from North Sky, *J. Opt. Soc. Am.* **53**, 626 (1963).
7. S. T. Henderson and D. Hodgkiss, The spectral energy distribution of daylight, *Br. J. Appl. Phys.* **14**, 125 (1963).
8. D. B. Judd, D. L. MacAdam and G. Wyszecki, Spectral distribution of typical daylight as a function of correlated color temperature, *J. Opt. Soc. Am.* **54**, 1031 (1963).
9. A. W. S. Tarrant, The spectral power distribution of daylight, *Trans. Illum. Eng. Soc.* **33**, 75 (1968).
10. W. D. Wright, *The measurement of colour*, 4th Edn, Adam Hilger, London, 1969.
11. D. B. Judd and G. Wyszecki, *Color in Business, Science and Industry*, 3rd Edn., Wiley-Interscience, New York, 1975.
12. G. Wyszecki and W. S. Stiles, *Color Science*, Wiley-Interscience, New York, 1967.
13. D. B. Judd, A Maxwell triangle yielding uniform chromaticity scales, *J. Res. Natl Bur. Stand.* **14**, 41, RP 756 (1935).
14. G. J. Chamberlin, *The CIE International Colour System Explained*, 2nd Edn, Tintometer Ltd, Salisbury, 1955.
15. F. C. Breckenridge and W. R. Schaub, Rectangular uniform chromaticity scale co-ordinates, *J. Opt. Soc. Am.* **29**, 370 (1939).
16. D. Farnsworth, *The Farnsworth rectilinear uniform chromaticity scale diagram No. 38*

Memorandum Ref 44-1 New London, Conn., Med. Research Lab. US Submarine Base, 1944.

17. R. K. Schofield, The Lovibond Tintometer adapted . . . to the CIE system, *J. Sci. Inst.* **XVI**, 74 (1939).

18. D. L. MacAdam, Projective transformations of I.C.I. Color specifications, *J. Opt. Soc. Am.* **27**, 294 (1937).

19. Commission Internationale de L'Eclairage Publication No. 15, *Colorimetry,* Supplement 2, 1976. (See Ref. 2 above.)

20. Geraldine W. Haupt, J. C. Scheleter and K. L. Eckerle, *The ideal Lovibond Color System for CIE standard Illuminants A and C shown in three colorimetric systems,* Heat Division, Institute for Basic Standards, National Bureau of Standards, Washington DC, 1972. NBS Technical Note 716.

21. K. MacLaren, The development of the CIE 1976 (L*a*b*) uniform colour space and colour-difference formula, *J. Soc. Dyers Colour.* **92**, 338 (1976).

22. D. G. Chamberlin, Lovibond Illuminant Cyan, *Colour 1977* (Report of the 3rd Congress of the International Colour Assn), Adam Hilger, London, 1977, p. 228.

23. D. L. MacAdam, The specification of small chromaticity differences, *J. Opt. Soc. Am.* **33**, 18 (1943).

24. F. J. J. Clarke and P. R. Samways, *The spectrophotometric properties of a selection of ceramic tiles,* Report MC2 NPL, London, 1968.

25. F. J. J. Clarke, Goniophotometry and use of ceramic colour standards, *Colour 73* (Report of 2nd Congress of the International Colour Association), Adam Hilger, London, 1973, p. 346.

26. F. Malkin, International comparison of instruments using the ceramic colour standards, *Colour 73* (Report of 2nd congress of the International Colour Association), Adam Hilger, London, 1973, p. 351.

COLOUR DATA TRANSFORMATION AND THE ROLE OF THE COMPUTER

5.1 INTRODUCTION

In the preceding chapter it has been shown how an internationally accepted system for colour specification has been derived. It is perhaps worth reiterating at this stage, that colour by its defined nature can only be properly measured by eye, while the physicist concentrates on the measurement of the stimulus giving rise to this sensation. These two methods of approach were irreconcilable until it was possible to calculate how a measured stimulus would appear to an observer. The decisions taken by the CIE in 1931[1] led to the definition of a standardized observer, reacting in exactly defined ways to any known stimulus, and embodying the known average response of a number of actual observers.

Implicit in the decisions then taken is the assumption that one of the colorimetrist's basic tools for measurement and research would be the spectrophotometer, giving as it does detailed spectral information which allows the scientist to predict the behaviour and appearance of colours on the basis of general laws.

It is of interest to note that very few people in 1930 could have foreseen that this instrument, in its many forms, would soon be found outside the major research laboratories and would indeed be used in great numbers for a wide variety of industrial and commercial applications. As anyone who has ever studied spectrophotometric data will appreciate, a curve or a column of figures is not readily appreciable in terms of the colour appearance they represent. This has meant that an ever increasing number of people are obliged to learn something of the CIE system and must transform their recorded data into its tristimulus values and chromaticity coordinates.

Equally, in each busy laboratory, an increasing amount of time has had to be set aside for the calculation of these results. The mathematics of calculating CIE chromaticity coordinates is not complex. The difficulty lies only in the large number of separate steps involved in each such calculation, and in checking

finally that each has been carried out correctly. The tables of values most frequently used give distribution coefficients weighted by the energy values of a given illuminant at 10 nm intervals throughout the visible spectrum, from 380 to 770 nm. Thus a total of 40 spectrophotometric values are required in order to carry out one full calculation. This column of 40 figures is multiplied at each wavelength by each of the three values given for the eye's response, and the results form three separate columns which, when added together, give the three tristimulus values. These values show the quantities of each of three stimuli needed by the standard observer to match this particular sample. As has already been explained, these values are each divided by the sum total of the three to give their proportions or chromaticity coordinates x, y and z, of which the first two can be plotted on the 1931 chromaticity diagram. Only the second tristimulus value (Y) remains of interest, as it represents the luminance of the sample.

Thus, in a single calculation one must carry out 120 separate multiplications each involving three or four-digit numbers; then add up three columns of 40 figures each, and finally, divide the total of each by the total of the three.

Since the authors hope that this book will be read by many who are newcomers to colour science, this calculation is set out in full in Table 5.1. The first column gives wavelengths at which the sample has been measured.

The second column shows the transmittance of the sample (in the example, a single Lovibond glass, 5.0 Blue). The percentage transmittance at each wavelength is shown divided by 100 in column 2. The sum of all the figures recorded in column 7 (44.50529) can then be read directly as the percentage transmittance of the sample, i.e. 44.5%. Columns 3, 4 and 5 are the distribution coefficients for CIE Illuminant C.[2]

Each figure in column 2 is multiplied in turn by the corresponding figures in columns 3, 4, and 5 and the results are tabulated in columns 6, 7, and 8.

Both authors have worked in small scale industry where facilities cannot be taken for granted, and can appreciate fully that while it is simple enough to learn to carry out such calculations, it is at best a chore. The supreme art for those engaged in industry lies not so much in understanding the complexity as in remembering exactly where one was in the calculation when last interrupted!

The purpose of this chapter is to discuss some of the ways in which this chore has been made easier by the use of computers. The problem itself is not too difficult to understand and this understanding is vital to good computer programming. Also, most of the figures will remain constant from one calculation to another and only the sample data needs to be altered for each new calculation.

It has become something of a commonplace to say that the advent of the computer brought about a revolution in a given field, from town planning to weather forecasting. However, in the case of colour measurement this was not strictly true in the early years. This is one field of study which is properly the concern of many groups, only some of whom are connected with research

TABLE 5.1
Calculation of tristimulus values and chromaticity coordinates, using distribution coefficients for CIE Illuminant C

(1) Wavelength	(2) Sample	(3) \bar{x}	(4) \bar{y}	(5) \bar{z}	(6) $S \times \bar{x}$	(7) $S \times \bar{y}$	(8) $S \times \bar{z}$
380	0.991	0.0036	0.0000	0.0164	0.00357	0.00000	0.01625
390	0.990	0.0183	0.0004	0.0870	0.01812	0.00040	0.08613
400	0.989	0.0841	0.0021	0.3992	0.08317	0.00208	0.39481
410	0.986	0.3180	0.0087	1.5159	0.31355	0.00858	1.49468
420	0.979	1.2623	0.0378	6.0646	1.23579	0.03701	5.93724
430	0.969	2.9913	0.1125	14.6019	2.89857	0.11870	14.14294
440	0.956	3.9741	0.2613	19.9357	3.79924	0.24980	19.05853
450	0.941	3.9191	0.4432	20.6551	3.68787	0.41705	19.43645
460	0.920	3.3668	0.6920	19.3235	3.09746	0.63664	17.77762
470	0.879	2.2878	1.0605	15.0550	2.01098	0.93218	13.23335
480	0.816	1.1038	1.6129	9.4220	0.90070	1.31613	7.68835
490	0.738	0.3639	2.3591	5.2789	0.26856	1.74102	3.89583
500	0.670	0.0511	3.4077	2.8717	0.03424	2.28316	1.92404
510	0.587	0.0898	4.8412	1.5181	0.05271	2.84178	0.89112
520	0.508	0.5752	6.4491	0.7141	0.29220	3.27614	0.36271
530	0.433	1.5206	7.9357	0.3871	0.65842	3.43616	0.16761
540	0.407	2.7858	9.1470	0.1956	1.13382	3.72283	0.07961
550	0.469	4.2833	9.8343	0.0860	2.00887	4.61229	0.04033
560	0.492	5.8782	9.8387	0.0381	2.89207	4.84064	0.01875
570	0.462	7.3230	9.1476	0.0202	3.38323	4.22619	0.00933
580	0.366	8.4141	7.9897	0.0147	3.07956	2.92423	0.00538
590	0.271	8.9878	6.6283	0.0101	2.43569	1.79627	0.00274
600	0.262	8.9536	5.3157	0.0067	2.34584	1.39271	0.00176
610	0.278	8.3294	4.1788	0.0029	2.31557	1.16171	0.00081
620	0.286	7.0604	3.1485	0.0012	2.01927	0.90047	0.00034
630	0.278	5.3212	2.1948		1.47929	0.61015	
640	0.256	3.6882	1.4411		0.94418	0.36892	
650	0.265	2.3531	0.8876		0.62357	0.23521	
660	0.292	1.3589	0.5028		0.39680	0.14682	
670	0.398	0.7113	0.2606		0.28310	0.10372	
680	0.545	0.3657	0.1329		0.19931	0.07243	
690	0.715	0.1721	0.0621		0.12305	0.04440	
700	0.847	0.0806	0.0290		0.06827	0.02456	
710	0.926	0.0398	0.0143		0.03685	0.01324	
720	0.962	0.0183	0.0064		0.01760	0.00616	
730	0.980	0.0085	0.0030		0.00833	0.00294	
740	0.986	0.0040	0.0017		0.00394	0.00168	
750	0.989	0.0017	0.0006		0.00168	0.00059	
760	0.990	0.0008	0.0003		0.00079	0.00030	
770	0.990	0.0003			0.00030		
		98.0699	100.0000	118.2216	45.15613	44.50529	106.67301

organizations or firms able to afford the cost of a separate computer. It would be nearer the mark to say that the real revolution began with the advent of the computer terminal during the 1960s, which enabled many companies to hire a terminal and modem unit and to use a computer at a distance; thus avoiding the large capital expense of a separate computer installation with its associated running costs.

Indeed, a feature of such a system which may bewilder newcomers is the fact that they will often use a computer thousands of miles away whose exact location they need never know.

In the early days of the use of computers for colour calculation, there was a dearth of information on this particular aspect of the subject. Those who wrote about programming were not colour scientists and those with knowledge in this field were not able to enter into a lengthy correspondence on the subject. For this reason, some examples of simple programs, which may be of help to the beginner, are illustrated and discussed. No special merit is claimed for them, except that if they can provide the beginner with the help he needs, then they will have served their purpose. The language used is BASIC, as implemented on the Honeywell Mark III network.[3, 4]

Let us start with certain assumptions. This chapter is intended as a guide for those who already know how to carry out a calculation, such as is shown in Table 5.1, and who have access to a computer terminal and are able to study the operating manual for the BASIC language.[3, 4] The initial difficulty then lies in grasping how to present sets of instructions and figures in meaningful sequence in a computer program. It is felt that this is most readily learned by studying existing patterns.

The BASIC language has been chosen intentionally as it is widely used and understood. It has the added advantage for the beginner that most statements have to be put on separate lines, thus making them somewhat easier to follow at this early stage.

5.2 'COLOUR 1': CALCULATION OF TRISTIMULUS VALUES AND CHROMATICITY COORDINATES FOR A SINGLE ILUMINANT

Each program must be identified by a name, not exceeding eight characters in length and for the present purpose each of the following programs will be named COLOUR, followed by a number. The first such program is 'COLOUR 1', shown in Table 5.2. It is a useful practice to begin with line number 100 and to increase by 10 at each step. In this way there is enough space left between each line to add further instructions or data and ensure that they come in the correct sequence.

Note that use of the REM(ark) statement allows the programmer to remind himself as well as others exactly where data come from and what the program is supposed to achieve at any point. These statements will be listed with the program, but will not in any way affect its running, i.e. the statements are ignored by the computer.

The heading in lines 100–110 serves to outline the purpose of the program and also to identify the results when these are printed at the end of each calculation. The DIM(ension) statement in line 140 reserves space in the computer storage for the data blocks which are to be a part of the program. Note that in line 160,

TABLE 5.2
**'COLOUR 1' computer program for the calculation of tristim-
ulus values and chromaticity coordinates**

```
100   PRINT"      TRISTIMULUS VALUES AND CHROMATICITY COORDINATES OF"
110   PRINT"      ANY SAMPLE IN CIE ILLUMINANT C - USING 1931 DATA."
120 PRINT
130 PRINT
140   DIM    A(40), B(40), C(40), T(40)
150   FOR I = 1 TO 40
160     READ A(I), B(I), C(I)
170   NEXT I
180 REM  READ DISTRIBUTION COEFFICIENTS WEIGHTED FOR ILLUMINANT C.
190   FOR I = 1 TO 40
200     READ T(I)
210   NEXT I
220 REM  READ AND STORE TRANSMITTANCE/REFLECTANCE VALUES OF SAMPLE.
230     X = 0
240     Y = 0
250     Z = 0
260 REM  ZERO OUT TRISTIMULUS VALUES.
270   FOR I = 1 TO 40
280     X = X + A(I) * T(I)
290     Y = Y + B(I) * T(I)
300     Z = Z + C(I) * T(I)
310   NEXT I
320 REM  COMPLETES CALCULATION OF TRISTIMULUS VALUES.
330 PRINT"   X              Y              Z              X           Y"
340 PRINT
350 PRINT
360    PRINT USING 370,       X, Y, Z, X/(X+Y+Z), Y/(X+Y+Z)
370:###.####     ###.####     ###.####     #.####     #.####
380 REM  DISTRIBUTION COEFFICIENTS WEIGHTED BY CIE ILLUMINANT C.
390 REM  DATA TAKEN FROM W.D.WRIGHT,ED.4,PAGE 322.
400 REM  DATA READ AS TRIPLETS IN ORDER X,Y,Z.  SEE LINE 160.
410   DATA .0036,0,.0164, .0183,.0004,.0870, .0841,.0021,.3992
420   DATA .3180,.0087,1.5159, 1.2623,.0378,6.0646, 2.9913,.1225,14.6019
430   DATA 3.9741,.2613,19.9357, 3.9191,.4432,20.6551
440   DATA 3.3668,.6920,19.3235, 2.2878,1.0605,15.0550
450   DATA 1.1038,1.6129,9.4220, .3639,2.3591,5.2789, .0511,3.4077,2.8717
460   DATA .0898,4.8412,1.5181, .5752,6.4491,.7140, 1.5206,7.9357,.3871
470   DATA 2.7858,9.1470,.1956, 4.2833,9.8343,.0860, 5.8782,9.8387,.0381
480   DATA 7.3230,9.1476,.0202, 8.4141,7.9897,.0147, 8.9878,6.6283,.0101
490   DATA 8.9536,5.3157,.0067, 8.3294,4.1788,.0029, 7.0604,3.1485,.0012
500   DATA 5.3212,2.1948,0, 3.6882,1.4411,0, 2.3531,.8876,0
510   DATA 1.3589,.5028,0,.7113,.2606,0, .3657,.1329,0, .1721,.0621,0
520   DATA .0806,.0290,0, .0398,.0143,0, .0183,.0064,0, .0085,.0030,0
530   DATA .0040,.0017,0, .0017,.0006,0, .0008,.0003,0, .0003,0,0
540 REM  CHECK DATA  -  BLANK.
550   DATA  1,1,1,1,1,1,1,1,1,1
560   DATA  1,1,1,1,1,1,1,1,1,1
570   DATA  1,1,1,1,1,1,1,1,1,1
580   DATA  1,1,1,1,1,1,1,1,1,1
999 END
```

the computer is instructed to read the first 120 pieces of data (each separated by a comma) as 40 'triplets'. The first, fourth, seventh and so on values are assigned to block A; the second, fifth, eighth etc. to block B, while the third, sixth, ninth etc. form block C. It is vital that the nature of the statement in line 160 should correspond with the way in which data are entered in lines 410–530, i.e. in order $\bar{x}, \bar{y}, \bar{z}$. Sample data, identified by T, are read and stored separately.

At the start of each calculation, X, Y and Z are made equal to zero. Lines 270–310 show the calculation at each of 40 steps of tristimulus values X, Y and Z. At the command, 'FOR I = 1 TO 40', the computer takes each distribution

coefficient in turn and multiplies it by the sample value at the same wavelength. The three totals are kept separate and this process is repeated 39 times until the running totals become the three tristimulus values. Line 360 directs the computer to print the values of X, Y and Z and of the two chromaticity coordinates x and y; while the image statement in line 370 ensures that the figures printed are rounded up, shortened to manageable proportions and neatly spaced. It is important to note here that calculating results by means of a computer will not make the original, measured, data any more accurate. Accuracy will still depend upon the choice of spectrophotometer and the care with which it is used. Chromaticity coordinates given to more than four places of decimals have little meaning in the world of industrial colour measurement.

COLOUR 1 is now complete except for a series of values for T, representing the spectral reflectance or transmittance of any sample. At this point it is convenient to test the program with a set of values which represent 100% transmittance or reflectance at each wavelength. This will allow the running of the program and the accuracy of each figure in the data blocks to be checked. The totals and proportions will be the tristimulus values and chromaticity coordinates of Illuminant C, as found in any textbook. The check sample data are given in lines 550–580 as 40 unity values and the program is formally terminated with END in line 999.

On the command, RUN, the computer executes COLOUR 1 and prints the headings and answers at the specified spacing as shown below in Table 5.3.

TABLE 5.3
Print-out of check calculation using 'COLOUR 1'

COLOUR 1 15:57 05/18/77

TRISTIMULUS VALUES AND CHROMATICITY COORDINATES OF ANY SAMPLE IN CIE ILLUMINANT C—USING 1931 DATA

X	Y	Z	X	Y
98.0699	100.0000	118.2216	.3101	.3162

Reference to the standard data,[2] confirms that the results are correct and that the program can now be used with any sample data.

New data is inserted by re-typing line numbers 550–580 with ten new values in each one. This information is recorded on paper-tape or on punched cards which can then be read at speed by the terminal. The transmittance values for a Lovibond 5.0 blue glass are given below (Table 5.4). When the tape containing these data is run, the computer will automatically erase the values previously held in these line numbers and will replace them with the latest values given. On the command, RUN, the result for the new sample will be printed out as shown in Table 5.4 under the heading 'COLOUR 1'.

TABLE 5.4
Data and calculated tristimulus values for Lovibond 5.0 blue glass

```
540  REM  LOVIBOND  5.0  BLUE

550  DATA  .991, .990, .989, .986, .979, .969, .956, .941, .920, .879
560  DATA  .816, .738, .670, .587, .508, .433, .407, .469, .492, .462
570  DATA  .366, .271, .262, .278, .286, .278, .256, .265, .292, .398
580  DATA  .545, .715, .847, .926, .962, .980, .986, .989, .990, .990
READY
RUN
COLOUR 1
```

TRISTIMULUS VALUES AND CHROMATICITY COORDINATES OF
ANY SAMPLE IN CIE ILLUMINANT C—USING 1931 DATA

X	Y	Z	X	Y
45.1561	44.5053	106.6730	.2300	.2267

COLOUR 1 thus performs the calculation of tristimulus values and chromaticity coordinates of any sample for one Illuminant, and a calculation which might have taken 45 min by hand has been shortened to 3 or 4 minutes only (the time taken to type a set of data and run the program).

This constitutes a starting point and some of the added complexity which can be written into the program can now be considered.

5.3 'COLOUR 2': CALCULATIONS ON MULTIPLE SAMPLES FOR ILLUMINANTS A AND C

This first program 'COLOUR 1' has certain obvious limitations. At the end of each calculation the single set of sample data must be replaced by fresh data. This not only involves the operator in loss of time, but means that he must be in attendance at all times when a batch of samples are to be calculated. It would clearly be an advantage if all the data for the batch could be prepared at one time and included with the program for processing. Then the operator could (in theory at least) leave the terminal unattended while a series of results were calculated and printed out. In this case some means of identifying each sample as the results appear must be included in the program.

Again, there are numerous occasions when it would be an advantage to know the chromaticity coordinates of a sample in at least two illuminants, e.g. CIE Illuminants A and C. It would be desirable not to have to enter the same data twice in different programs in order to achieve this end.

Another consideration is that, in many industries, tristimulus values and chromaticity coordinates in the CIE 1931 system[1] serve merely as the basis for further transformations into the coordinates of one of several uniform chromaticity triangles currently in use. It should be the object of a programmer

to produce exactly the final data needed and to avoid the need for any subsequent manual calculation.

In the next program, COLOUR 2, the original program has been rewritten to fulfil these requirements. The quantity of data now forming an integral part of the program has been doubled by including the distribution coefficients for both CIE Illuminants A and C.[2] These data are found in lines 1000–1290. The data are again listed in triplet form $(\bar{x}, \bar{y}, \bar{z})$ and this corresponds with the READ statements in lines 140–200. There is no technical reason why the data need be so listed, as they could easily be entered as separate data blocks for \bar{x} only, \bar{y} only and \bar{z} only. In this case, however, six separate statements of the type:

```
FOR   I = 1 TO 40
         READ A (I)
NEXT I
```

would be required instead of the two statements found here. The authors' preference is for a shorter, neater section of READ statements, although each programmer is free to choose his own format.

Two uniform chromaticity scales are used in the program. The first was proposed by Judd of the National Bureau of Standards in 1935[5] and has chromaticity coordinates r, g and b. This scale is important commercially as it is widely used and quoted in the colour grading of petroleum products, vegetable oils and rosins. The transformation formulae from CIE coordinates x, y to r, g are as follows:

$$r = \frac{2.7760x + 2.1543y - 0.1192}{-1.0000x + 6.3553y + 1.5405}$$

$$g = \frac{-2.9446x + 5.0323y + 0.8283}{-1.0000x + 6.3553y + 1.5405}$$

The second transformation used is from coordinates x and y to the coordinates u and v of the uniform chromaticity scale adopted by the CIE in 1960.[6]

The conversion formulae for this scale are:

$$u = \frac{4x}{-2x + 12y + 3}$$

$$v = \frac{6y}{-2x + 12y + 3}$$

Again, it should be pointed out that these two scales have no special significance. Rather, they are used here to show how any such transformation formulae can be included in a program and it is acknowledged that many industries have particular preferences as to which scales are used.

In Table 5.5, the revised computer program is printed in full.

TABLE 5.5
'COLOUR 2' computer program for calculations on multiple samples for CIE Illuminants A and C

```
100 PRINT "PERCENTAGE TRANSMITTANCE & CHROMATICITY COORDINATES IN THREE"
110 PRINT "COLORIMETRIC SYSTEMS FOR CIE ILLUMINANTS A & C.  1931 DATA."
120 PRINT
130 DIM  A(40),B(40),C(40),D(40),E(40),F(40),T(40)
140    FOR I = 1 TO 40
150        READ A(I), B(I), C(I)
160    NEXT I
170 REM READ AND STORE DISTRIBUTION COEFFICIENTS FOR ILLUMINANT A.
180    FOR I = 1 TO 40
190        READ D(I), E(I), F(I)
200    NEXT I
210 REM READ AND STORE DISTRIBUTION COEFFICIENTS FOR ILLUMINANT C.
220    READ U
230 REM REFERS TO NUMBER OF SAMPLES RECORDED IN LINE 1300.
240        FOR V = 1 TO U
250        READ A$
255        PRINT V;
260        PRINT"          SAMPLE  IS   "; A$
270            FOR I = 1 TO 25
280                PRINT"-";
290                PRINT" ";
300            NEXT I
310            FOR I = 1 TO 40
320                READ T(I)
330            NEXT I
340 REM   READ TRANSMITTANCE/REFLECTANCE DATA.
350                GOSUB 390
360        NEXT V
370    GO TO 9999
380 REM   END OF MAIN SEQUENCE.
390    X = 0
400    Y = 0
410    Z = 0
420    X1 = 0
430    Y1 = 0
440    Z1 = 0
450 REM ZERO OUT TRISTIMULUS VALUES.
460 FOR I = 1 TO 40
470        X = X + A(I) * T(I)
480        Y = Y + B(I) * T(I)
490        Z = Z + C(I) * T(I)
500        X1 = X1 + D(I) * T(I)
510        Y1 = Y1 + E(I) * T(I)
520        Z1 = Z1 + F(I) * T(I)
530 NEXT I
540 REM CALCULATE TRISTIMULUS VALUES FOR ILLUMINANTS A AND C.
550 G = X + Y + Z
560 H = X1 + Y1 + Z1
570 J = X/G
580 K = Y/G
590 J1 = X1/H
600 K1 = Y1/H
610 L = (2.7760 * J) + (2.1543 * K) - .1192
620 M = (-1 * J) + (6.3553 * K) + 1.5405
630 N = (-2.9446 * J) + (5.0323 * K) + .8283
640 O = L/M
650 P = N/M
660 L1 = (2.7760 * J1) + (2.1543 * K1) - .1192
670 M1 = (-1 * J1) + (6.3553 * K1) + 1.5405
680 N1 = (-2.9446 * J1) + (5.0323 * K1) + .8283
690 O1 = L1/M1
700 P1 = N1/M1
710 REM TRANSFORM TO COORDINATES OF JUDD'S UNIFORM CHROMATICITY SCALE.
720 Q = (12 * K) - (2 * J) + 3
730 R = (4 * J)/Q
740 S = (6 * K)/Q
```

TABLE 5.5—*continued*

```
750 Q1 = (12 * K1) - (2 * J1) + 3
760 R1 = (4 * J1)/Q1
770 S1 = (6 * K1)/Q1
780 REM TRANSFORM TO COORDINATES OF CIE UNIFORM CHROMATICITY SCALE.
790 PRINT" YAZ        XA        YA        RA       GA       UA        VA"
800 PRINT USING 810, Y,J,K,O,P,R,S
810:###.##      #.####    #.####   #.###   #.###    #.####   #.####
820 PRINT
830 PRINT
840 PRINT" YCZ        XC        YC        RC       GC       UC        VC"
850 PRINT USING 860, Y1,J1,K1,O1,P1,R1,S1
860:###.##      #.####    #.####   #.###   #.###    #.####   #.####
870 REM PRINT OUT HEADINGS AND VALUES FOR ILLUMINANTS A AND C.
880   PRINT
890   PRINT
900   PRINT
910     PRINT TAB (18); "*";
920         FOR I = 1 TO 10
930             PRINT" ";
940             PRINT"*";
950         NEXT I
960   PRINT
970   PRINT
980   PRINT
990 RETURN
1000 REM   DISTRIBUTION COEFFICIENTS WEIGHTED BY CIE ILLUMINANT A
1010 REM   TAKEN FROM W.D.WRIGHT, ED.4, PAGE 322.
1020 DATA .001,0,.0048,.0046,.0001,.0219,.0193,.0005,.0916
1030 DATA .0688,.0019,.3281,.2666,.008,1.2811,.6479,.0265,3.1626
1040 DATA .9263,.0609,4.6469,1.032,.1167,5.4391,1.0207,.2098,5.8584
1050 DATA .7817,.3624,5.1445,.4242,.6198,3.6207,.1604,1.0398,2.3266
1060 DATA .0269,1.7956,1.5132,.0572,3.0849,.9674,.4247,4.7614,.5271
1070 DATA 1.2116,6.323,.3084,2.3142,7.5985,.1625,3.7329,8.5707,.0749
1080 DATA 5.5086,9.2201,.0357,7.571,9.4574,.0209,9.7157,9.2257,.017
1090 DATA 11.5841,8.543,.013,12.7103,7.546,.0096,12.6768,6.3599,.0044
1100 DATA 11.3577,5.0649,.002,8.9999,3.7122,0,6.5487,2.5587,0
1110 DATA 4.3447,1.6389,0,2.6234,.9706,0,1.4539,.5327,0
1120 DATA .7966,.2896,0,.4065,.1467,0,.2067,.0744,0,.1108,.0398,0
1130 DATA .0556,.0195,0,.028,.01,0,.0144,.0062,0,.0063,.0021,0
1140 DATA .0032,.0011,0,.0011,0,0
1150 REM   DISTRIBUTION COEFFICIENTS WEIGHTED BY CIE ILLUMINANT C
1160 REM   TAKEN FROM W.D.WRIGHT, ED.4, PAGE 322.
1170 DATA .0036,0,.0164,.0183,.0004,.087,.0841,.0021,.3992
1180 DATA .318,.0087,1.5159,1.2623,.0378,6.0646,2.9913,.1225,14.6019
1190 DATA 3.9741,.2613,19.9357,3.9191,.4432,20.6551,3.3668,.692,19.3235
1200 DATA 2.2878,1.0605,15.055,1.1038,1.6129,9.422,.3639,2.3591,5.2789
1210 DATA .0511,3.4077,2.8717,.0898,4.8412,1.5181,.5752,6.4491,.714
1220 DATA 1.5206,7.9357,.3871,2.7858,9.147,.1956,4.2833,9.8343,.086
1230 DATA 5.8782,9.8387,.0381,7.323,9.1476,.0202,8.4141,7.9897,.0147
1240 DATA 8.9878,6.6283,.0101,8.9536,5.3157,.0067,8.3294,4.1788,.0029
1250 DATA 7.0604,3.1485,.0012,5.3212,2.1948,0,3.6882,1.4411,0
1260 DATA 2.3531,.8876,0,1.3589,.5028,0,.7113,.2606,0,.3657,.1329,0
1270 DATA .1721,.0621,0,.0806,.029,0,.0398,.0143,0,.0183,.0064,0
1280 DATA .0085,.003,0,.004,.0017,0,.0017,.0006,0
1290 DATA .0008,.0003,0,.0003,0,0
1300   DATA   2
1310   DATA   BLANK.
1320 DATA   1,1,1,1,1,1,1,1,1,1
1330 DATA   1,1,1,1,1,1,1,1,1,1
1340 DATA   1,1,1,1,1,1,1,1,1,1
1350 DATA   1,1,1,1,1,1,1,1,1,1
1360   DATA   LOVIBOND BLUE 5.0
1370 DATA   .991,.990,.989,.986,.979,.969,.956,.941,.920,.879
1380 DATA   .816,.738,.670,.587,.508,.433,.407,.469,.492,.462
1390 DATA   .366,.271,.262,.278,.286,.278,.256,.265,.292,.398
1400 DATA   .545,.715,.847,.926,.962,.980,.986,.989,.990,.990
9999 END
```

A few points in the program in Table 5.5 deserve mention in more detail. The title in the opening lines will be printed once only and serves to outline the program for future reference. In line 130, the DIM(ension) statement must now reserve space for six data blocks, each containing forty numbers. These are the distribution coefficients for Illuminants A and C. At the same time one must reserve one data block for sample data (T). This is all that is needed since no matter how many samples are to be processed, only one set of data will be held in the memory at a given time.

Lines 140–200 contain the instructions to read and store the distribution coefficients for each Illuminant, as already discussed above.

The instructions in lines 220–360 form the basis of this new program and contain a number of separate commands. These ensure that each block of sample data is taken separately; and that its identifying title is printed out according to a standard format, and is underlined. The sample data are then read, stored and used in a subroutine which calculates and prints the chromaticity coordinates and transmittance values. The final instruction, in line 360, is the direction to move to the next block of sample data and to repeat the process until each sample has been calculated.

Now look at these instructions in more detail. Line 220 directs the processor to read a figure (U) showing the number of samples entered in the program. This figure is recorded in the program in line 1300 and must, in this case, be the first piece of data entered after the distribution coefficients. Line 240 directs that a value (V) be recorded. Initially zero, this value becomes 1 as the first sample is processed, and 2 as the second sample is read and processed, and increases by 1 for each sample in turn. The direction to read the next sample in sequence is found in line 360. When the value of V (the number of samples calculated) equals the value of U (the number of samples entered) the program directs the processor to line 370 and from there to the final instruction in line 9999 which ensures an orderly termination of the program.

Line 250 gives the instruction to read the first item of data from the first sample. This is found in line 1310 and is a name or number used to identify the sample. The form A$ allows the programmer to use an alphanumeric string (a sequence of letters and numbers) to identify each sample. The instruction, PRINT V; in line 255 ensures that the number of each sample is printed in the left-hand margin, while the semicolon means that the title will be printed on the same line.

This title will be printed in the standard format given in line 260. Lines 270–300 give instructions to underline this title and then lines 310–330 direct that the first set of 40 figures are read and stored. The next instruction, 'GOSUB 390' directs the processor to use these 40 values in the series of calculations forming the subroutine from lines 390 to 950. This subroutine is itself terminated by the command, 'RETURN' in line 990, directing the processor back to line 250, so that the title of the next sample is read and printed.

The sequence of instructions in this subroutine will now be more familiar.

First, zero out the tristimulus values for both Illuminants and then calculate new values using the current sample data and the distribution coefficients in lines 1000–1290. Lines 550–770 ensure that these coordinates are transformed into the coordinates of the two uniform chromaticity triangles discussed above.

Lines 790 and 840 print appropriate headings for each of the desired values. These calculated values are given in lines 800 and 850; first for Illuminant A and then for Illuminant C. The image statements in lines 810 and 860 ensure that results are rounded up and spaced uniformly. The coordinates r and g of Judd's uniform chromaticity triangle are given to three places of decimals only, since greater accuracy is not called for in current specifications.

Some mention should be made here of the style of format chosen. Programmers will usually differ on the manner in which data are presented. Such decisions as whether to print results in columns or lines, how widely to space and how to identify each result, will depend largely on the preferences of each programmer and of the audience he serves. Anyone who has watched a computer terminal working will have been struck by its alarming capacity for generating waste paper and it was during the sudden paper shortage in Britain of 1974 that the authors' own program was altered to pack a maximum of information into a modest space. It has since been found convenient to retain this format as some thousands of results are filed away each year, and presenting these in well-spaced vertical columns would treble the volume of paper to be stored.

Lines 910–950 give instructions which formally mark the end of each calculation and separate individual samples by printing a half line of stars across the page.

The entire subroutine from line 390 is terminated by the command 'RETURN' in line 990. If this instruction is omitted, the program will only carry out a single calculation and will then terminate.

The program 'COLOUR 2', as shown in Table 5.5, contains two sets of data, declared in line 1300. The first is a blank, or test sample, as before, and the second, a Lovibond 5.0 Blue glass. On the command RUN, 'COLOUR 2' will calculate the results for both these samples and print the results as shown in Table 5.6.

The two sets of data shown are sufficient to demonstrate the working of the program and no valid point would be served in giving further worked examples at this stage. It is now possible to enter large numbers of samples for processing at one time adding additional data in sequence after line number 1400. It is recommended that the same, or a similar, format should be adopted when preparing data, i.e. a total of five lines for each sample, with the sample identifier in the first line, followed by four lines of transmittance or reflectance values. It is good practice to let each line contain 10 figures as shown in previous examples. A standard system of this type is a great help in checking the number of values in each sample as this is crucial for accuracy. Each sample entered must have exactly forty values for it to comply with the requirements of this program.

TABLE 5.6
Results from 'COLOUR 2'

```
PERCENTAGE TRANSMITTANCE & CHROMATICITY COORDINATES IN THREE
COLORIMETRIC SYSTEMS FOR CIE ILLUMINANTS A & C.  1931 DATA.

   1            SAMPLE  IS    BLANK.
 - - - - - - - - - - -   - - - - - - - - - - - - -
   YAZ           XA           YA          RA         GA           UA          VA
 130.00         .4476        .4075       .543        .424        .2560       .3495

   YCZ           XC           YC          RC         GC           UC          VC
 100.00         .3101        .3162       .439        .465        .2049       .3073

               *   *   *   *   *   *   *   *   *   *   *

   2            SAMPLE  IS    LOVIBOND  BLUE  5.0
 - - - - - - - - - - -   - - - - - - - - - - - - -
   YAZ           XA           YA          RA         GA           UA          VA
 43.08          .3554        .3633       .472        .461        .2138       .3279

   YCZ           XC           YC          RC         GC           UC          VC
 44.51          .2300        .2267       .366        .470        .1749       .2586

               *   *   *   *   *   *   *   *   *   *
```

By entering large numbers of samples for calculation at the same time, the user, with a terminal linked to one of the major networks, is able to delay processing by up to several hours. This means that computing will be done at off-peak hours and the results stored in such a way that they can later be listed. It is possible to save from 40 to 60% of computing costs by this means, but the use of such options does put greater responsibility on the user to ensure that both program and sample data are accurately entered. The detailed instructions for such a deferred run will be found in the handbooks, but one useful hint can be given which enables the user to check the running of the program.

Let us assume that the program 'COLOUR 2' has been entered and includes first the 'blank' sample as shown, here, followed by another set of known data and then two hundred unknown samples for calculation. It is obviously vital to check the running of the program, and there are two points at which the amount of data handled can be controlled. The first of these is line 990 and the second is line 1300. By deleting line 990 the programmer ensures that the computer will only calculate the first sample. Check that the chromaticity coordinates printed are those for Illuminants A and C, and these data blocks can be assumed to be correct. As an additional control reinsert 990 RETURN and enter 1300 DATA 2. Now, the first two sets of sample data will be calculated and printed as already shown, while the remainder of the data is ignored. Only when these initial checks have proved satisfactory should the operator alter line 1300 to read: 1300 DATA 202. On the next command, RUN, the computer will execute the program and will now be directed to return to the start of the subroutine in

line 390 two hundred and one times, such that results for both sets of check data and for all two hundred samples are listed.

A brief summary of computing capability would now be as follows. 'COLOUR 2' will accept spectral reflectance or transmittance data at 10 nm intervals from 380 to 770 nm and reduce this to tristimulus values and chromaticity coordinates of the 1931 system for two illuminants. The colour matching functions are found in one of the standard text books on the subject where they are adjusted to be specific for a particular illuminant. It has been seen how the coordinates can be transformed into those of two other uniform chromaticity scale diagrams. Further, 'COLOUR 2,' will accept large quantities of sample data at one time and will identify each result as it is printed out. A program such as this may well serve the routine needs of many laboratories.

From a study of this program, it will be clear that it can easily be altered to accept data for other illuminants, such as Illuminant D_{65}. In this case, the data for this new illuminant can replace that for Illuminant C and all references to C must be altered to refer to D_{65} within the program. A further modification, which need not be explained in detail, concerns altering the program to accept spectral data at 5 nm intervals, where this represents the standard intervals at which certain samples must be measured. In this case, the headings and the distribution coefficients contained in lines 1000–1290 must be replaced by the new coefficients.[7] Note that new dimensions must be declared in lines 130, 140, 180, 310 and 460 and that the test data in lines 1320–1350 must now contain seventy-nine figures. The check glass entered at line 1360, and which represents any known standard, should also be re-measured and seventy-nine values given.

There is one particular aspect of computing which will quickly become apparent to anyone using a computer for the first time. This is the range of complex work which can now be tackled with relative ease. 'Complex' in this context means a computational task, just sufficiently time consuming that without the aid of a computer, it would tend to be deferred indefinitely, unless there was a pressing need for the answer.

5.4 'COLOUR 3': GENERAL CALCULATION USING ANY SOURCE/FILTER COMBINATION AS THE ILLUMINANT

In 'COLOUR 1' and 'COLOUR 2' colour matching functions have been used which are found in most standard text books and in which the standard observer's response is given for a specific illuminant. These data embody the eye response, the spectral power data of an illuminant and, in the case of Illuminants B and C, the spectral transmittance data of the filter specified to alter Illuminant A to give the appearance of either B or C. Such compound data is sufficient for the majority of purposes and the preparation of such tables in the early 1930s, represented a significant saving of time. However, there are occasions when it is necessary to calculate the chromaticity of a sample from basic data as found in CIE technical document 15 [8] and in which eye response, illuminant and filter

TABLE 5.7
Calculation of tristimulus values and chromaticity
coordinates from basic data

(1) Wavelength	(2) \bar{x}	(3) \bar{y}	(4) \bar{z}	(5) Ill.A	(6) D.G. Filter
	Colour matching functions				
380	0.0014		0.0065	9.80	0.529
390	0.0042	0.0001	0.0201	12.09	0.615
400	0.0143	0.0004	0.0679	14.71	0.675
410	0.0435	0.0012	0.2074	17.68	0.714
420	0.1344	0.0040	0.6456	20.99	0.733
430	0.2839	0.0116	1.3856	24.67	0.714
440	0.3483	0.0230	1.7471	28.70	0.663
450	0.3362	0.0380	1.7721	33.09	0.587
460	0.2908	0.0600	1.6692	37.81	0.511
470	0.1954	0.0910	1.2876	42.87	0.453
480	0.0956	0.1390	0.8130	48.24	0.402
490	0.0320	0.2080	0.4652	53.91	0.351
500	0.0049	0.3230	0.2720	59.86	0.293
510	0.0093	0.5030	0.1582	66.06	0.243
520	0.0633	0.7100	0.0782	72.50	0.210
530	0.1655	0.8620	0.0422	79.13	0.194
540	0.2904	0.9540	0.0203	85.95	0.186
550	0.4334	0.9950	0.0087	92.91	0.178
560	0.5945	0.9950	0.0039	100.00	0.165
570	0.7621	0.9520	0.0021	107.18	0.1479
580	0.9163	0.8700	0.0017	114.44	0.1338
590	1.0263	0.7570	0.0011	121.73	0.1199
600	1.0622	0.6310	0.0008	129.04	0.1090
610	1.0026	0.5030	0.0003	136.35	0.1016
620	0.8544	0.3810	0.0002	143.62	0.0961
630	0.6424	0.2650		150.84	0.0914
640	0.4479	0.1750		157.98	0.0871
650	0.2835	0.1070		165.03	0.0838
660	0.1649	0.0610		171.96	0.0801
670	0.0874	0.0320		178.77	0.0756
680	0.0468	0.0170		185.43	0.0710
690	0.0227	0.0082		191.93	0.0654
700	0.0114	0.0041		198.26	0.0604
710	0.0058	0.0021		204.41	0.0555
720	0.0029	0.0010		210.36	0.0509
730	0.0014	0.0005		216.12	0.0467
740	0.0007	0.0002		221.67	0.0435
750	0.0003	0.0001		227.00	0.0409
760	0.0002	0.0001		232.12	0.0392
770	0.0001			237.01	0.0385

(7) Product of (3) × (5) × (6)	(8) Sample	(9)	(10) Products of columns	(11)
		(2) × (5) × (6) × (8)	(7) × (8)	(4) × (5) × (6) × (8)
	0.991	0.00719		0.03339
0.00074	0.990	0.03092	0.00073	0.14796
0.00397	0.989	0.14043	0.00393	0.66678
0.01515	0.986	0.54144	0.01494	2.58146
0.06154	0.979	2.02441	0.06025	9.72440
0.20433	0.969	4.84570	0.19800	23.64988
0.43765	0.956	6.33588	0.41839	31.78126
0.73811	0.941	6.14500	0.69456	32.39013
1.15925	0.920	5.16904	1.06651	29.67043
1.76723	0.879	3.33553	1.55340	21.97969
2.69555	0.816	1.51280	2.19957	12.86513
3.93586	0.738	0.44687	2.90466	6.49640
5.66509	0.670	0.05758	3.79561	3.19630
8.07445	0.587	0.08763	4.73970	1.49070
10.80975	0.508	0.48958	5.49135	0.60482
13.23275	0.433	1.10009	5.72978	0.28051
15.25131	0.407	1.88951	6.20728	0.13208
16.45529	0.469	3.36159	7.71753	0.06748
16.41750	0.492	4.82615	8.07741	0.03166
15.09103	0.462	5.58131	6.97206	0.01538
13.32150	0.366	5.13515	4.87567	0.00953
11.04874	0.271	4.05939	2.99421	0.00435
8.87524	0.262	3.91434	2.32531	0.00295
6.96814	0.278	3.86119	1.93714	0.00116
5.25852	0.286	3.37261	1.50394	0.00079
3.65350	0.278	2.46214	1.01567	
2.40801	0.256	1.57776	0.61645	
1.47976	0.265	1.03898	0.39214	
0.84021	0.292	0.66323	0.24534	
0.43248	0.398	0.47012	0.17213	
0.22381	0.545	0.33580	0.12198	
0.10293	0.715	0.20373	0.07359	
0.04910	0.847	0.11563	0.04159	
0.02382	0.926	0.06093	0.2206	
0.01071	0.962	0.02987	0.01030	
0.00505	0.980	0.01385	0.00495	
0.00193	0.986	0.00666	0.00190	
0.00093	0.989	0.00275	0.00092	
0.00091	0.990	0.00180	0.00090	
	0.990	0.00090		

Total (column 7) = 166.72184 75.25548 74.20185 177.82462
Weighting Factor = 100/166.72184 = 0.59980
Total of columns, 9, 10 and 11 = 327.28195
Coordinate x = 75.25548/327.28195 = 0.230
Coordinate y = 74.20185/327.28195 = 0.227
Transmittance factor = 74.20185 × 0.59980 = 44.51%

TABLE 5.8
'COLOUR 3' computer program for general calculation using any source/filter combination

```
100 PRINT "REFLECTANCE/TRANSMITTANCE AND CHROMATICITY COORDINATES OF A"
110 PRINT "  SAMPLE IN ANY COMBINATION OF SOURCE AND FILTER USED TO"
120 PRINT "              SIMULATE CIE. ILLUMINANT C."
130 PRINT
140 PRINT
150  DIM  A(40), B(40), C(40), D(40), E(40), F(40)
160    FOR I = 1 TO 40
170       READ A(I), B(I), C(I)
180    NEXT I
190 REM READ AND STORE SPECTRAL TRISTIMULUS VALUES.
200    FOR I = 1 TO 40
210       READ D(I)
220    NEXT I
230 REM READ AND STORE DATA FOR SOURCE.
240    FOR I = 1 TO 40
250       READ E(I)
260    NEXT I
270 REM READ AND STORE DATA FOR FILTER.
280    FOR I = 1 TO 40
290       Y = Y + B(I) * D(I) * E(I)
300    NEXT I
310    K = 100/Y
320 REM  CALCULATE WEIGHTING VALUE TO CORRECT TRISTIMULUS VALUES.
330    READ U
340 REM  REFERS TO NUMBER OF SAMPLES RECORDED IN LINE 1150.
350       FOR V = 1 TO U
360       READ A$
370       PRINT V;
380       PRINT"    SAMPLE  IS   "; A$
390          FOR I = 1 TO 25
400             PRINT"-";
410             PRINT" ";
420          NEXT I
430             FOR I = 1 TO 40
440                READ F(I)
450             NEXT I
460 REM  READ TRANSMITTANCE/REFLECTANCE DATA OF SAMPLE.
470                GOSUB 510
480          NEXT V
490 REM  END OF MAIN SEQUENCE.
500          GO TO 9999
510 X = 0
520 Y = 0
530 Z = 0
540 FOR I = 1 TO 40
550    X = X + (A(I) * D(I) * E(I) * K) * F(I)
560    Y = Y + (B(I) * D(I) * E(I) * K) * F(I)
570    Z = Z + (C(I) * D(I) * E(I) * K) * F(I)
580 NEXT I
590 REM  CALCULATES TRISTIMULUS VALUES (WEIGHTED) OF SAMPLE.
600  G = X/(X+Y+Z)
610  H = Y/(X+Y+Z)
620 REM CALCULATE CHROMATICITY COORDINATES X AND Y.
630    J = (12*H) - (2*G) + 3
640    L = (4*G)/J
650    M = (6*H)/J
660 REM TRANSFORM TO COORDINATES U AND V OF CIE UNIFORM CHROMATICITY
670 REM SCALE (1960).
```

TABLE 5.8—*continued*

```
680 PRINT
690 PRINT
700 PRINT"      Y%              X         Y              U        V"
710 PRINT
720 PRINT
730 PRINT USING 740,  Y, G, H, L, M
740:####.##              ##.###   ##.###        ##.###   ##.###
750 REM PRINT CAP. Y(%) AND COORDINATES X,Y AND U,V.
760 PRINT
770 PRINT
780 PRINT
790   PRINT TAB (16); "*";
800      FOR I = 1 TO 10
810          PRINT"  ";
820          PRINT"*";
830       NEXT I
840 PRINT
850 PRINT
860 PRINT
870 RETURN
880 REM SPECTRAL TRISTIMULUS VALUES. TABLE 2.3.1. FROM CIE. DOCUMENT 15.
890 REM   DATA BLOCKS A, B AND C.
900 DATA .0014,0,.0065,.0042,.0001,.0201,.0143,.0004,.0679
910 DATA .0435,.0012,.2074,.1344,.004,.6456,.2839,.0116,1.3856
920 DATA .3483,.023,1.7471,.3362,.038,1.7721,.2908,.06,1.6692
930 DATA .1954,.091,1.2876,.0956,.139,.813,.032,.208,.4652
940 DATA .0049,.323,.272,.0093,.503,.1582,.0633,.71,.0782
950 DATA .1655,.862,.0422,.2904,.954,.0203,.4334,.995,.0087
960 DATA .5945,.995,.0039,.7621,.952,.0021,.9163,.87,.0017
970 DATA 1.0263,.757,.0011,1.0622,.631,.0008,1.0026,.503,.0003
980 DATA .8544,.381,.0002,.6424,.265,0,.4479,.175,0,.2835,.107,0
990 DATA .1649,.061,0,.0874,.032,0,.0468,.017,0,.0227,.0082,0
1000 DATA .0114,.0041,0,.0058,.0021,0,.0029,.001,0,.0014,.0005,0
1010 DATA .0007,.0002,0,.0003,.0001,0,.0002,.0001,0,.0001,0,0
1020 REM   RELATIVE SPECTRAL POWER DISTRIBUTION OF STANDARD
1030 REM   ILLUMINANT A. TABLE 1.1.1. CIE DOCUMENT 15.   DATA BLOCK D.
1040 DATA 9.8, 12.09, 14.71, 17.68, 20.99, 24.67, 28.7, 33.09, 37.81
1050 DATA 42.87, 48.24, 53.91, 59.86, 66.06, 72.5, 79.13, 85.95, 92.91
1060 DATA 100, 107.18, 114.44, 121.73, 129.04, 136.35, 143.62, 150.84
1070 DATA 157.98, 165.03, 171.96, 178.77, 185.43, 191.93, 198.26
1080 DATA 204.41, 210.36, 216.12, 221.67, 227, 232.12, 237.01
1090 REM   TRANSMITTANCE OF DAVIS-GIBSON CELL TO CONVERT
1100 REM   ILLUMINANT A TO ILLUMINANT C - MEASURED DATA. DATA BLOCK E.
1110 DATA .529,.615,.675,.714,.733,.714,.663,.587,.511,.453
1120 DATA .402,.351,.293,.243,.210,.194,.186,.178,.165,.1479
1130 DATA .1338,.1199,.1090,.1016,.0961,.0914,.0871,.0838,.0801,.0756
1140 DATA .0710,.0654,.0604,.0555,.0509,.0467,.0435,.0409,.0392,.0385
1150 DATA 2
1160 DATA   TEST DATA   -   BLANK.
1170 DATA   1,1,1,1,1,1,1,1,1,1
1180 DATA   1,1,1,1,1,1,1,1,1,1
1190 DATA   1,1,1,1,1,1,1,1,1,1
1200 DATA   1,1,1,1,1,1,1,1,1,1
1210 DATA   LOVIBOND 5.0 BLUE FILTER.
1220 DATA   .991,.990,.989,.986,.979,.969,.956,.941,.920,.879
1230 DATA   .816,.738,.670,.587,.508,.433,.407,.469,.492,.462
1240 DATA   .366,.271,.262,.278,.286,.278,.256,.265,.292,.398
1250 DATA   .545,.715,.847,.926,.962,.980,.986,.989,.990,.990
9999 END
```

are defined separately. In a colour laboratory there are often occasions when a sample will be viewed by a source other than Illuminant A and modified by a filter which may depart from the values specified for a Davis–Gibson filter.[9] Provided that all these values can be adequately measured, the programmer must be able to calculate the coordinates of the sample under these exact conditions. However, note how this technique affects the calculation shown in Table 5.1

A revision of the previous calculation is shown in Table 5.7. Here, columns 2, 3 and 4 show the 1931 CIE Standard Observer colour matching functions as found in Table 2.3.1 of CIE Document 15.[8] Column 5 gives the relative spectral power distribution of Illuminant A and column 6 gives the transmittance data for a two-chambered Davis–Gibson cell to convert A to C. Column 8 gives the sample data, while columns 7, 9, 10 and 11 show the products of several columns as shown in the heading. It should be noted here that the colour matching functions given in columns 2, 3 and 4 are not weighted by the values of any illuminant. The technique of weighting adjusts the colour matching functions in such a manner that the tristimulus value Y gives the reflectance or transmittance of the sample directly as a percentage. This weighting is specific to a single illuminant only and must be repeated whenever the illuminant is changed. In Table 5.7 this weighting factor is found by multiplying each figure in column 3 by the corresponding figures in columns 5 and 6. These products are listed under column 7. The reciprocal of the total in column 7 is found by dividing one hundred by the total and this figure is used as the weighting factor. Now find coordinates x and y from the totals of columns 9, 10 and 11. Transmittance is found by multiplying the total of column 10 by this weighting factor. It would be a somewhat daunting prospect to carry out repeated calculations by hand along these lines and it is in such cases that a computer's ability to handle more complex problems is appreciated.

The next program, 'COLOUR 3', (Table 5.8) was written to handle this more general calculation. An outline of the program purpose is given in the heading in lines 100–120. Lines 150–270 contain the dimension statement and instructions to read and store the blocks of data. The calculation of the weighting factor, as found in column 7 in Table 5.7 is carried out in lines 280–310 by finding the total of tristimulus value Y integrated with the values of the illuminant and the filter. K is the reciprocal of this value and represents the weighting factor for this combination of source and filter. Note that the value of Y must be returned to zero before starting the calculation of tristimulus values, X, Y and Z in lines 540–580, and this is accomplished in line 520. In line 330 the processor will again read the number of samples to be calculated and then for each sample in turn will print this number and the sample identification which is then underlined. Lines 430–450 contain the instructions to read the first set of sample data and then go to the subroutine starting at line 510. Initially, each of the tristimulus values is made equal to zero.

Each such value becomes the product of the spectral tristimulus value, the

relative spectral power distribution and the transmittance factor of the Davis–Gibson cell, weighted by the value of K and finally integrated with the spectral reflectance or transmittance of the sample. Without the use of this weighting factor, K, the relative proportions of the tristimulus values and, therefore, the chromaticity coordinates would remain unaltered. Only the value of Y would be incorrect and therefore the reflectance or transmittance could not be read from the results. Lines 600–670 calculate the chromaticity coordinates x and y from the weighted tristimulus values and again transform these to the coordinates u and v of the 1960 uniform chromaticity diagram.[6] The following lines give instructions for printing headings and the values of Y and of the two sets of coordinates, in accordance with the image statement in line 740. The results of each calculation are again underlined by means of the subroutine in lines 790–830 and the command, RETURN in line 870 directs the processor back to read the next set of sample data, before re-entering the subroutine. The data blocks referred to in the program are again listed at the end of the program and their origin clearly marked. The two familiar sets of test data are also included.

On the command, RUN, the results will again be listed as shown in Table 5.9.

TABLE 5.9
Results from 'COLOUR 3'

REFLECTANCE/TRANSMITTANCE AND CHROMATICITY COORDINATES OF A
SAMPLE IN ANY COMBINATION OF SOURCE AND FILTER USED TO
SIMULATE CIE. ILLUMINANT C.

1	SAMPLE	IS	TEST DATA	-	BLANK.		
Y%		X	Y		U	V	
100.00		.310	.316		.201	.307	

* * * * * * * * * *

2	SAMPLE	IS	LOVIBOND	5.0	BLUE FILTER.		
Y%		X	Y		U	V	
44.51		.230	.227		.175	.259	

* * * * * * * * * *

Now, consider an actual case where the sample (the 5.0 Blue glass) is viewed by a combination of a Tungsten Halogen lamp and a Chance OB 8 filter glass in place of the Davis–Gibson cell.[9] Data blocks D and E are replaced with the appropriate measured data, as shown in Table 5.10 and the program is run again to produce the results in Table 5.11.

TABLE 5.10
Measured data for lamp/filter combination

```
1020 REM   RELATIVE SPECTRAL POWER DISTRIBUTION OF TUNGSTEN HALOGEN
1030 REM   LAMP AS MEASURED.     DATA BLOCK D.
1040 DATA  19.6, 22.9, 26.3, 30.2, 34.2, 38.3, 42.8, 47.3, 51.8
1050 DATA  56.7, 61.3, 66.1, 71.2, 76.2, 81.2, 86.1, 90.6, 95.4
1060 DATA  100, 104.3, 108, 112, 116, 118.9, 121.6, 125.7, 128.5
1070 DATA  131.8, 134.5, 137.2, 138.6, 140.5, 142.9, 144.3, 145.7
1080 DATA  147.3, 148.1, 148.9, 148.9, 151
1090 REM   TRANSMITTANCE OF GLASS FILTER TO CORRECT LAMP TO
1100 REM   ILLUMINANT C.  MEASURED DATA.  DATA BLOCK E.
1110 DATA  .729,.778,.803,.797,.721,.696,.650,.611,.568,.522
1120 DATA  .481,.440,.411,.382,.359,.328,.304,.294,.294,.281
1130 DATA  .259,.230,.219,.209,.190,.170,.151,.148,.154,.173
1140 DATA  .198,.219,.225,.222,.216,.209,.201,.194,.185,.178
KEY
READY
RUN
```

TABLE 5.11
Results from 'COLOUR 3' using new data

```
REFLECTANCE/TRANSMITTANCE AND CHROMATICITY COORDINATES OF A
SAMPLE IN ANY COMBINATION OF SOURCE AND FILTER USED TO
              SIMULATE CIE. ILLUMINANT C.

  1      SAMPLE IS  TEST DATA  -  BLANK.
- - - - - - - - - - - - - - - - - - - - - - -

     Y%            X         Y              U          V

  100.00          .318      .336           .199       .315

          *   *   *   *   *   *   *   *   *   *   *

  2      SAMPLE IS  LOVIBOND 5.0 BLUE FILTER.
- - - - - - - - - - - - - - - - - - - - - - -

     Y%            X         Y              U          V

   44.31          .237      .247           .173       .270

          *   *   *   *   *   *   *   *   *   *   *
```

For the purposes of this chapter it is sufficient to note that there are significant differences between the two sets of results. It is not always possible to work with a correct Illuminant A source and a correct Illuminant C filter in the laboratory. Now, however, given that instrumentation is available for accurate measurement of both source and filter, COLOUR 3 enables the experimenter to calculate chromaticities with values which represent the actual set of spectral power data as opposed to an assumed set used in the first two programs.

In the three programs so far discussed, examples have been given of how spectrophotometric data can be transformed, using a computer, to produce

transmittance or reflectance values, together with the chromaticity coordinates of three colour triangles. These programs are given in detail to provide a basis for anyone starting in this field with no prior experience in writing programs. However, one thing is certain—that within a few weeks of starting, any beginner will have re-written these programs to suit his own needs. Much of the interest in programming lies in the fact that the program is so versatile. It can be altered to suit the particular needs of any laboratory both as to content and presentation, and the layout of the program can be altered to achieve the most economical use of space. With this goal in mind, no other programs are presented solely for the purpose of reducing spectrophotometric data. Rather, two other programs will be discussed which involve different aspects of computing and in which techniques are used which can be applied in other cases, such as modified versions of 'COLOUR 1', 'COLOUR 2' or 'COLOUR 3'.

5.5 'COLOUR 4': PROGRAM TO PLOT COMPARATIVE TRANSMITTANCE CURVES

The first of these new programs, the fourth in the sequence and therefore named 'COLOUR 4', shows a routine for graph plotting. This technique is frequently useful and is well described in the literature. The present program has been written particularly for plotting spectrophotometric data against the curve formed by the Lovibond glasses which match a particular sample.

The Lovibond scales used here are the Lovibond Schofield scales as defined in 1939.[10] These three scales, Red, Yellow and Blue, are sufficiently defined by giving the internal transmittance of the unit value at every wavelength from 380 to 770 nm. A Lovibond number now represents the power to which the unit transmittance values must be raised at each wavelength to determine the spectral curve of that number. When a combination of two scales is used to match a sample, the two sets of values so found are multiplied together to give the spectral curve of the combination. As information in this form is often needed by the authors, it was found worthwhile to prepare a program specially for this purpose. One problem encountered is that the type of terminal commonly used has only 72 character spaces across the paper and, if the transmittance scale is to be plotted horizontally, it can therefore only be recorded in steps of 2%.

In this instance the previous procedure is reversed and an example of such a graph is first given (Fig. 5.1), after which the program itself is discussed in greater detail. In Fig. 5.1 the transmittance of a daylight filter is shown plotted against the compound transmittance curve of Lovibond 0.5 Red and 7.8 Blue, values which were found to give a visual match to this glass.

The graph shown is representative of a type which can easily be plotted. The transmittance scale increases in steps of 2% as mentioned and is repeated below the graph to facilitate reading. Sufficient information is given at the bottom of the page to show exactly which values are plotted.

This program (Table 5.12), seemingly complex at first glance, can be broken

down into a few simpler sections for study. Lines 100–260 contain the now familiar instructions to print a program title, reserve space for the blocks of data shown in lines 1040–1230 and to print a further explanatory heading above the upper line of the graph.

Now, consider the instructions in lines 270–510. These same instructions are repeated in lines 690–910 and together they give each step necessary for plotting the upper and lower horizontal transmittance scales. Two features are used extensively in this part of the program. One is the use of the TAB function and the other is the semi-colon. The TAB function causes the printing head to move to a position which is a specified number of spaces from the left hand margin, before printing a letter or value. The semi-colon is again used to keep the printing head on the same line while a series of print instructions are carried out.

It is possible to mark fifty transmittance values at 2% intervals and the single

Fig. 5.1. Computer plot of spectral transmittance curves using 'COLOUR 4'.

' ' character encloses each line of figures and dashes. The first instruction therefore is for the printing head to move six places to the right and print the ' ' character. Still on the same line, it will now print the figure zero, followed by nine dashes. The next figure to be printed is twenty, followed by eight dashes, and so on until the last figure of one hundred is printed. Next, the single ' ' character is again printed and serves to enclose the whole line. The spacing has been adjusted such that the actual values corresponding to 0, 20, 40, 60% transmittance and so on, lie under the figures zero, two, four, six etc. As mentioned above, once the graph has been plotted, these instructions are repeated again in lines 690–910, thus making the values on the graph far easier to read.

The calculation of the two sets of values is achieved by the two lines 550 and 560 and the remaining lines in the loop from 540–680 ensure the correct placing of each value. The wavelengths of interest are again the forty values from 380 to 770 nm and, by setting wavelength equal to 370 in line 530, a single instruction in line 570 within this loop now ensures that the correct wavelengths will be printed in a vertical column down the left-hand margin. Now, at each of 40 wavelengths the value of T becomes the measured transmittance value of the unit Red glass raised to the power 0.5 multiplied by the transmittance value of the unit Blue glass raised to the power 7.8. This product is multiplied by fifty in order to fit the scale of the graph and 0.5 is added to round the figure up. After this the nearest integral value is taken. Similarly, the value of T1 becomes the transmittance value of the sample, multiplied again by fifty, plus 0.5 and again the nearest whole number is chosen. The functions FNF and FNR are defined in lines 120 and 130. The wavelength (W) now increases by 10 nm and the first instruction is to print the value of W; then, on the same line, the print head tabulates to position number six and 'I' is printed. The vertical line formed by these capital Is gives a base line to the graph. Now, if the value T1 is less than T then the print head tabulates to the value T1 plus seven and prints a plus sign; then tabulates to the value T plus seven and prints a star. If the value of T is less than the value of T1 the print head tabulates to the value T plus seven and prints a star; then tabulates to the value T1 plus seven and prints a plus sign. The third possible case is when the two values are equal and in this case the instruction in line 660 is to tabulate to the value T1 plus seven and print an X. Returning to line 540 this whole process is repeated thirty-nine times over until all the values have been calculated and printed. The lower margin is then added and the values which have been calculated are printed out below the graph. These are the values found in lines 960, 980 and 1000 and serve to identify each graph.

To draw further plots using this same program, but with different Lovibond values, it is only necessary to change the instructions in line 550 and the corresponding identification in line 960. To plot the curve of Lovibond values against any other sample, first change the sample data in the last four lines of the program and the identification in line 980.

TABLE 5.12
'COLOUR 4' computer program, to plot comparative transmittance curves

```
100 PRINT" PROGRAM TO COMPARE TRANSMITTANCE CURVE OF ANY COMBINATION"
110 PRINT" OF LOVIBOND GLASSES WITH THE SPECTRAL CURVE OF ANY SAMPLE."
120   DEF FNF (T) = INT (T + .5)
130   DEF FNR (T1) = INT (T1 + .5)
140 PRINT
150 PRINT
160 PRINT
170 DIM  R(40),Y(40),B(40),S(40)
180 FOR I = 1 TO 40
190 READ R(I),Y(I),B(I)
200 NEXT I
210 REM   READ AND STORE TRANSMITTANCE VALUES FOR UNITS OF LOVIBOND
220 REM   RED, YELLOW AND BLUE SCALES.
230 FOR I = 1 TO 40
240 READ S(I)
250 NEXT I
260 REM   READ AND STORE TRANSMITTANCE/REFLECTANCE VALUES OF SAMPLE.
270 PRINT"          TRANSMITTANCE:  FROM 0 TO 100 IN STEPS OF 2%."
280 PRINT
290 PRINT TAB (6); "'";
300       PRINT "0";
310       FOR I = 1 TO 9
320       PRINT "-";
330       NEXT I
340       PRINT "20";
350       FOR I = 12 TO 19
360       PRINT "-";
370       NEXT I
380       PRINT "40";
390       FOR I = 22 TO 29
400       PRINT "-";
410       NEXT I
420       PRINT "60";
430       FOR I = 32 TO 39
440       PRINT "-";
450       NEXT I
460       PRINT "80";
470       FOR I = 42 TO 49
480       PRINT "-";
490       NEXT I
500       PRINT "100";
510 PRINT ""
520 REM   PRINT OUT HEADINGS AS TRANSMITTANCIES AT 20% INTERVALS.
530 W = 370
540 FOR I = 1 TO 40
550       T = FNF (50 * (R(I)↑.5 * B(I)↑7.8))
560       T1 = FNR (50 * S(I))
570       W = W + 10
580       PRINT W;
590       PRINT TAB (6); "I";
600       IF T1 < T THEN 640
610       IF T1 = T THEN 660
620       PRINT TAB (T+7); "*"; TAB (T1+7); "+"
630       GO TO 680
640       PRINT TAB (T1+7); "+"; TAB (T+7); "*"
650       GO TO 680
660       PRINT TAB (T1+7); "X"
670       GO TO 680
680 NEXT I
```

TABLE 5.12—*continued*

```
690 PRINT TAB (6); "'";
700         PRINT "0";
710         FOR I = 1 TO 9
720         PRINT "-";
730         NEXT I
740         PRINT "20";
750         FOR I = 12 TO 19
760         PRINT "-";
770         NEXT I
780         PRINT "40";
790         FOR I = 22 TO 29
800         PRINT "-";
810         NEXT I
820         PRINT "60";
830         FOR I = 32 TO 39
840         PRINT "-";
850         NEXT I
860         PRINT "80";
870         FOR I = 42 TO 49
880         PRINT "-";
890         NEXT I
900         PRINT "100";
910 PRINT "'"
920 REM  PRINT OUT HEADINGS AS LOWER MARGIN OF GRAPH.
930    PRINT
940    PRINT
950    PRINT
960    PRINT"        *  =  LOVIBOND VALUES   0.5 R + 7.8 B."
970    PRINT
980    PRINT"        +  =  TRANSMITTANCE CURVE OF CHANCE OB8 GLASS FILTER."
990    PRINT
1000   PRINT"        X  =  TRANSMITTANCE VALUES EQUAL."
1010 REM   INTERNAL TRANSMITTANCE VALUES OF THE LOVIBOND UNIT RED, YELLOW
1020 REM   AND BLUE GLASSES AS FOUND BY K. SCHOFIELD (1939).
1030 REM   DATA BLOCKS R, Y AND B.
1040 DATA .90258,.02889,.99815,.90352,.12593,.99809,.90439,.25435,.99788
1050 DATA .90603,.39957,.99711,.90737,.52037,.99573,.90824,.61634,.99363
1060 DATA .90886,.70289,.99111,.90858,.77822,.98800,.90722,.84481,.98338
1070 DATA .90444,.89471,.97459,.89819,.92976,.96004,.88633,.95277,.94109
1080 DATA .86526,.96755,.92316,.83257,.97738,.89900,.79598,.98364,.87326
1090 DATA .77392,.98754,.84574,.78952,.99040,.83553,.83317,.99195,.85049
1100 DATA .87817,.99236,.86792,.91300,.99247,.85702,.93628,.99179,.81808
1110 DATA .95268,.99073,.77002,.96362,.98933,.76498,.97109,.98768,.77420
1120 DATA .97648,.98599,.77827,.98053,.98438,.77386,.98348,.98333,.76119
1130 DATA .98572,.98287,.76656,.98753,.98279,.78191,.98892,.98330,.83172
1140 DATA .99012,.98405,.88572,.99117,.98449,.93507,.99194,.98510,.96744
1150 DATA .99247,.98627,.98466,.99303,.98789,.99228,.99336,.98912,.99587
1160 DATA .99365,.99014,.99719,.99402,.99108,.99770,.99420,.99160,.99790
1170 DATA .99430,.99210,.99800
1180 REM   TRANSMITTANCE OF A CHANCE OB8 FILTER AT A THICKNESS OF 2MM.
1190 REM   VALUES TAKEN FROM CATALOGUE.  DATA BLOCK S.
1200 DATA  .76, .81, .83, .80, .75, .70, .65, .60, .55, .50
1210 DATA  .46, .44, .40, .38, .35, .34, .33, .32, .32, .32
1220 DATA  .30, .27, .27, .25, .24, .22, .20, .20, .20, .21
1230 DATA  .23, .25, .26, .26, .25, .24, .23, .22, .21, .20
9999 END
```

TABLE 5.13
'COLOUR 5' computer program to calculate chromaticity coordinates and percent transmittance from tintometer data

```
100 CALL WARN (0)
110  DIM  R(40), Y(40), B(40), C(40), D(40), E(40)
120 PRINT" THIS PROGRAM CALCULATES THE CHROMATICITY COORDINATES AND "
130 PRINT" PERCENTAGE TRANSMITTANCE / REFLECTANCE OF ANY SAMPLE FOR "
140 PRINT"          C.I.E. ILLUMINANT C. USING THE 1931 DATA."
150 PRINT
160 PRINT
170 PRINT" INPUT VALUES IN ORDER: RED, YELLOW, BLUE, DENSITY"
180 PRINT" PUT COMMA BETWEEN EACH VALUE. OBSERVE SIGN OF DENSITY."
190 PRINT
200 PRINT
210   FOR I = 1 TO 40
220       READ R(I), Y(I), B(I)
230   NEXT I
240  REM  READ K-SCALE UNIT VALUES.
250   FOR I = 1 TO 40
260       READ C(I), D(I), E(I)
270   NEXT I
280  REM  READ DISTRIBUTION COEFFICIENTS FOR ILLUMINANT C.
290  REM   K-SCALE UNIT VALUES AS DEFINED BY SCHOFIELD (1939).
300 DATA .99258,.02889,.99815,.90352,.12593,.99809,.90439,.25435,.99788
310 DATA .90603,.39957,.99711,.90737,.52037,.99573,.90824,.61634,.99363
320 DATA .90886,.70289,.99111,.90858,.77822,.98800,.90722,.84481,.98338
330 DATA .90444,.89471,.97459,.89819,.92976,.96004,.88633,.95277,.94109
340 DATA .86526,.96755,.92316,.83257,.97738,.89900,.79598,.98364,.87326
350 DATA .77392,.98754,.84574,.78952,.99040,.83553,.83317,.99195,.85049
360 DATA .87817,.99236,.86792,.91300,.99247,.85702,.93628,.99179,.81808
370 DATA .95268,.99073,.77002,.96362,.98933,.76498,.97109,.98768,.77420
380 DATA .97648,.98599,.77827,.98053,.98438,.77386,.98348,.98333,.76119
390 DATA .98572,.98287,.76656,.98753,.98279,.78191,.98892,.98330,.83172
400 DATA .99012,.98405,.88572,.99117,.98449,.93507,.99194,.98510,.96744
410 DATA .99247,.98627,.98466,.99303,.98789,.99228,.99336,.98912,.99587
420 DATA .99365,.99014,.99719,.99402,.99108,.99770,.99420,.99160,.99790
430 DATA .99430,.99210,.99800
440  REM   DISTRIBUTION COEFFICIENTS WEIGHTED BY ILLUMINANT C.
450  REM   DATA FROM W.D. WRIGHT, EDITION 4, 1969  -  TABLE 8.
460  DATA .0036,0,.0164, .0183,.0004,.0870, .0841,.0021,.3992
470  DATA .3180,.0087,1.5159, 1.2623,.0378,6.0646
480  DATA 2.9913,.1225,14.6019, 3.9741,.2613,19.9357
490  DATA 3.9191,.4432,20.6551, 3.3668,.6920,19.3235
500  DATA 2.2878,1.0605,15.0550, 1.1038,1.6129,9.4220
510  DATA .3639,2.3591,5.2789, .0511,3.4077,2.8717
520  DATA .0898,4.8412,1.5181, .5752,6.4491,.7140
530  DATA 1.5206,7.9357,.3871, 2.7858,9.1476,.1956, 4.2833,9.8343,.0860
540  DATA 5.8782,9.8387,.0381, 7.3230,9.1476,.0202, 8.4141,7.9897,.0147
550  DATA 8.9878,6.6283,.0101, 8.9536,5.3157,.0067, 8.3294,4.1788,.0029
560  DATA 7.0604,3.1485,.0012
570  DATA 5.3212,2.1948,0, 3.6882,1.4411,0, 2.3531,.8876,0
580  DATA 1.3589,.5028,0, .7113,.2606,0, .3657,.1329,0, .1721,.0621,0
590  DATA .0806,.0290,0, .0398,.0143,0, .0183,.0064,0, .0085,.0030,0
600  DATA .0040,.0017,0, .0017,.0006,0, .0008,.0003,0, .0003,0,0
610  PRINT
620  PRINT
630  PRINT
640  PRINT"               SAMPLE = ";
650  INPUT Q$
660  PRINT
670  PRINT
680  PRINT"          RED, YELLOW, BLUE, DENSITY  ";
690  INPUT  R1, Y1, B1, D1
700  PRINT
710  PRINT
720  GOSUB 740
730   GO TO 640
740  X2 = 0
750  Y2 = 0
760  Z2 = 0
770  K = 0
780   FOR I = 1 TO 40
790       H = R(I)↑R1 * Y(I)↑Y1 * B(I)↑B1
800           X2 = X2 + H * C(I)
810           Y2 = Y2 + H * D(I)
820           Z2 = Z2 + H * E(I)
830   NEXT I
840       J = X2 + Y2 + Z2
```

TABLE 5.13—*continued*

```
850    M = X2/J
860    N = Y2/J
870   REM   CALCULATE C.I.E.(1931) CHROMATICITY COORDINATES.
880        P = (6*N) - (1*M) + 1.5
890        S = (2*M)/P
900        T = (3*N)/P
910   REM   TRANSFORM TO CIE - 1960 UCS COORDINATES.
920    IF D1 < 0 THEN 1260
930    IF D1 <= 1 THEN 990
940    IF D1 <= 2 THEN 1020
950    IF D1 <= 3 THEN 1050
960        D2 = 4 - D1
970        K = (10↑D2)/10000
980    GO TO 1080
990        D2 = 1 - D1
1000       K = (10↑D2)/10
1010   GO TO 1080
1020       D2 = 2 - D1
1030       K = (10↑D2)/100
1040   GO TO 1080
1050       D2 = 3 - D1
1060       K = (10↑D2)/1000
1070   GO TO 1080
1080 PRINT"  COORDINATES IN ILLUMINANT C."
1090 PRINT
1100 PRINT"     X          Y          U          V        SAMPLE(%)"
1110 PRINT
1120 PRINT USING 1130, M, N, S, T, (Y2*K)
1130: #.####   #.####    #.####   #.####      ###.##
1140 PRINT
1150 PRINT
1160    PRINT TAB (18); "*";
1170        FOR I = 1 TO 10
1180            PRINT"  ";
1190            PRINT "*";
1200        NEXT I
1210 PRINT
1220 PRINT
1230 PRINT
1240 RETURN
1250   GO TO 9999
1260       D2 = D1 * -1
1270    IF D2 <= 1 THEN 1330
1280    IF D2 <= 2 THEN 1360
1290    IF D2 <= 3 THEN 1390
1300        D3 = (4 - D2)
1310        K = (10↑D3)/10000
1320    GO TO 1420
1330        D3 = (1 - D2)
1340        K = (10↑D3)/10
1350    GO TO 1420
1360        D3 = (2 - D2)
1370        K = (10↑D3)/100
1380    GO TO 1420
1390        D3 = (3 - D2)
1400        K = (10↑D3)/1000
1410    GO TO 1420
1420 PRINT"  COORDINATES IN ILLUMINANT C."
1430 PRINT
1440 PRINT"     X          Y          U          V        SAMPLE(%)"
1450 PRINT
1460 PRINT USING 1470, M, N, S, T, (Y2/K)
1470: #.####   #.####    #.####   #.####      ###.##
1480 PRINT
1490 PRINT
1500    PRINT TAB (18); "*";
1510        FOR I = 1 TO 10
1520            PRINT"  ";
1530            PRINT"*";
1540        NEXT I
1550 PRINT
1560 PRINT
1570 PRINT
1580 RETURN
9999 END
```

TABLE 5.14
Typical results from 'COLOUR 5'

THIS PROGRAM CALCULATES THE CHROMATICITY COORDINATES AND
PERCENTAGE TRANSMITTANCE / REFLECTANCE OF ANY SAMPLE FOR
C.I.E. ILLUMINANT C. USING THE 1931 DATA.

INPUT VALUES IN ORDER: RED, YELLOW, BLUE, DENSITY
PUT COMMA BETWEEN EACH VALUE. OBSERVE SIGN OF DENSITY.

 SAMPLE = ? 1.

 RED, YELLOW, BLUE, DENSITY ? 0,0,0,0

COORDINATES IN ILLUMINANT C.

 X Y U V SAMPLE(%)

 .3101 .3162 .2009 .3073 100.00

 * * * * * * * * * * *

 SAMPLE = ? 2,

 RED, YELLOW, BLUE, DENSITY ? 5,0,0,0

COORDINATES IN ILLUMINANT C.

 X Y U V SAMPLE(%)

 .3550 .2851 .2486 .2995 56.26

 * * * * * * * * * * *

 SAMPLE = ? 3.

 RED, YELLOW, BLUE, DENSITY ? 0,10,0,0

COORDINATES IN ILLUMINANT C.

 X Y U V SAMPLE(%)

 .3999 .4720 .2034 .3601 85.79

 * * * * * * * * * * *

5.6 'COLOUR 5': CALCULATION OF CHROMATICITY COORDINATES AND TRANSMITTANCE CURVE FROM TINTOMETER DATA

The final computer program to be discussed in this chapter was written to replace the nomograms and table supplied with Lovibond Tintometers. Colours are matched with any two of the three scales, Red, Yellow and Blue and results

are recorded in terms of these Lovibond units, together with a figure for the visual density correction which must be added to either sample or reference field in order to balance the luminance. Nomograms are used to convert these instrument readings into CIE chromaticity coordinates, while the luminance is calculated from tables. This program was written for the benefit of those users who already have a desk-top computer or who have access to a computer terminal. It has been written in the input mode since the majority of users would wish to calculate results after each reading.

This program, 'COLOUR 5', can also be most conveniently studied by subdividing it into blocks. First come the dimension statements followed by the title in lines 120–140. The next two lines 170 and 180 contain instructions for the user to follow when running the program. There now follow two sets of instructions to read data; the first referring to the unit values of the Lovibond glasses in lines 300–430 and the second to the distribution coefficients weighted by Illuminant C as recorded in lines 460–600. Next, the computer at line 640 will print out, 'SAMPLE = ', followed by a question mark to show that some input is expected from the user. This input, to be decided by the user, will be one or more letters or figures identifying the sample. At line 680 the computer will again print out, 'RED, YELLOW, BLUE, DENSITY', followed by a question mark and the user is required to enter a series of Lovibond values and a density correction figure. These data will now be used in the subroutine which concludes the program.

At each one of forty intervals throughout the spectrum the value of H is first calculated as shown in line 790. This value H represents the transmittance of one or more of the unit glasses raised to the power of the Lovibond number as found from the instrument. At each wavelength this value H is multiplied by the three corresponding distribution coefficients in order to give the three running totals $X2$, $Y2$ and $Z2$. This is repeated 39 times until these values become the tristimulus values. Next the program will calculate the chromaticity coordinates, here identified as M and N, and use these to calculate the coordinates in the CIE 1960 uniform chromaticity scale.[6]

In the next part of the subroutine the value of D1 is used to calculate the transmittance or reflectance value of the sample. Shutters on either side of the lamp are used to control the amount of light entering either sample or reference field. The figure recorded with the results will be a visual density correction which may be either positive or negative. The sign of this figure is used to indicate whether the correction should be added to or subtracted from the known transmittance value of the Lovibond Glasses. In line 920 this figure is tested to see whether it is less than zero in which case the program jumps to the instructions in line 1260. If greater than zero, in other words positive, the program will follow lines 930–1070. This density correction figure D1 becomes a transmittance value D2 and this figure is used to correct the tristimulus value Y of the Lovibond glasses. The instructions for this final correction are made in the two print statements in lines 1120 and 1460. Again the results are preceded

by a heading and an image statement used to round up the figures to manageable proportions after which each set of figures is underlined before the program returns to line 640 to request input data for the next sample.

One final instruction needs to be explained and this occurs in the first line 100. The instruction CALL WARN (zero) is a function of this particular language and ensures that when the computer works with figures which are effectively zero, it does not print this fact before giving the results. For example the unit value of the Lovibond Yellow scale transmits only 2.8% at 380 nm. When this value is raised to the power 20, it becomes so small as to be regarded effectively as zero. It is not necessary to record this fact and indeed it will not affect the calculation of the chromaticity coordinates. The instruction in line 100 then, is used simply to conserve space and to cancel recording of information which is not strictly necessary.

This last program, 'COLOUR 5', is detailed in Table 5.13 and following it in Table 5.14 is a sample of the print-out obtained when the program is run. Three samples have been entered and three sets of Lovibond data given and in each case the figures underlined are those which the user must enter.

It is a telling comment on human nature that while a modern computer is never wrong and its ancillary equipment seldom at fault, the programmer, who represents the major source of error, will always ensure that the computer takes the blame for his own short-comings. Indeed, the time honoured phrase, 'computer error' may be used to cover anything from measuring the wrong sample to asking the wrong question.

However, a computer which could place the blame for any mistake unerringly on the guilty human would probably not be a saleable item and tales of the million pound domestic heating bill are firmly entrenched in our folklore.

In this context, the colorimetrist is fortunate indeed. In each of the five programs studied, the structure itself is relatively simple, while the answers must lie within certain known limits. In the case of each of the colour triangles mentioned, the chromaticity coordinates must always add up to one and a figure greater than unity is instantly suspect. Similarly, a reflectance or transmittance greater than 100% cannot be correct and will indicate which part of the program to check first.

No attempt has been made to deal with the many colour scales and colorimetric systems currently in use. The interested student is referred to Chapter 41 of a book by Francis and Clydesdale.[11] Here, the authors give a number of programs in FORTRAN IV for the interconversion of colour data from most colorimetric systems, as well as the calculation of colour tolerances.

REFERENCES

1. Commission Internationale de l'Eclairage, *Proc. 8th Session. Cambridge 1931*, Cambridge University Press, 1932, p. 19.
2. W. D. Wright, *The Measurement of Colour*, 4th Edn, Adam Hilger, London, 1969, Appendix III, Table 8.

3. Honeywell Reference Manual, *BASIC Language*, 1972, Mark III Network Service.
4. John G. Kemeny and Thos. E. Kurtz, *BASIC Programming*, 2nd Edn, Wiley, New York, 1971.
5. D. B. Judd, A Maxwell triangle yielding uniform chromaticity scales, *J. Res. Natl. Bur. Stand.* **14**, 41 (1935).
6. CIE Uniform Chromaticity Scale, *CIE Proceedings 1959* (Brussels). Bureau Central CIE, Paris, 1960.
7. W. D. Wright, *The Measurement of Colour*, 4th Edn, Adam Hilger, London, 1969, Appendix II Tables 5 and 7.
8. Commission Internationale de l'Eclairage, Technical Publication 15, *Colorimetry* Bureau Central CIE, Paris, 1971.
9. R. Davis and K. S. Gibson, Filters for the reproduction of sunlight and daylight, *Bur. Stand. Misc. Publ.* **114**, (1931).
10. R. K. Schofield, The Lovibond Tintometer adapted to the CIE system, *J. Sci. Inst.* **XVI**, 74 (1939).
11. F. J. Francis and F. M. Clydesdale, *Food Colorimetry: Theory and Applications*, AVI Publishing Co., Westport, 1975.

APPLICATIONS OF COLOUR MEASUREMENT

The uses of this tool, colorimetry, may appear to the uninitiated to be somewhat limited, but, to those involved, the horizon is always expanding. The 'man in the street' may be able to think of colour control in the paint and dyeing industries, and possibly would think of plastics and cosmetics to complete his list. In fact, there are few trades in which colour measurement does not play an important part. The keeping of samples for colour to check against future production is a risky business, as few materials are sufficiently permanent in colour, and a slow drift from the original colour is an almost inevitable result. This in itself would justify the search for a method to put figures to colours, but a detailed look soon shows that much more is involved. It is not often that absolute colorimetry is required: more often, some colour standard is fixed and agreed, and one needs to measure variation from that point. In other words, differential measurements are required, and these can be made with greater accuracy and economy than the more difficult absolute measurements. If the agreed standard and the sample to be assessed are a non-metameric pair, as is often the case, the work is that much simpler and shorter, but if a metameric pair is formed by the standard and the sample then only a full spectrophotometric measurement, converted to CIE coordinates, will give the required information.

6.1 PAINTS AND PRINTING INKS

When a shade card is issued by a manufacturer, customers will naturally expect an item ordered to be close in colour to the sample, although the complication enters here that the shade card is itself not permanent and will fade in time, especially if not kept in the dark. Much more important is to ensure that every tin of that reference number is the same as the last, so that a job started with one container can be completed with another. This entails the manufacturer in

keeping exact colour measurements; if he relies on a sample from the last batch, he will certainly be guilty of a 'drift' in colour. For general 'over the counter' trade, it is possible to take refuge behind the statement 'the maker cannot guarantee . . . etc.' and it is quite true that the economics of the situation may not justify an exact maintenance of precise colour standards; but where recurrent big contracts are involved, it is clearly imperative that great care be taken. To assist in such control, national as well as internal colour specifications are available.[1-3] To ensure reproducibility, the raw materials must also be colour-checked: the oils, varnishes and solvents used are measured by transmitted light in a glass or silica cell, and they must not vary, or if they do, due account must be taken and allowances made in the final blend. The pigments must be checked—usually by extending with a standard white in various suitable proportions and 'pulling down' on a white background adjacent to a standard sample which itself should be colour measured to see that it has not changed. When selecting his pigments, the paint maker will want to know their performance when exposed to light, heat, weathering, salt or chemical-fume-laden air, and so on, and these tests are made comparative by careful records of colour changes on sample panels which are subjected to the appropriate hazard.

To achieve a match to a customer's sample, trial and error methods can be shortened by a comparison of the measurements of the sample and the nearest stock line, and it is usually possible from the measurement of a trial mix to make appropriate adjustments.

Where parts of a manufactured article are made and painted in different locations for later assembly, such as sections of refrigerators, cookers, or motor cars, no variation between parts can be tolerated, and here colorimetry is a necessity, even (in fact more so) for white articles.

Similarly with printing inks. On a long run on the printing press, it may well happen that a fresh batch of ink has to be introduced in the middle of a run, and any variation could prove a commercial disaster. To avoid this the colours must be checked and the data recorded in the control room.

In some cases, an exact match may prove economically unreasonable, but even so a tolerance must be agreed between buyer and seller, and this (where large contracts are concerned) is usually stated in mathematical terms, such as CIE coordinates.

Rosins, used for varnish making, are graded for colour on one of the many standard colour scales issued by standardizing bodies, such as the USA Naval Stores Rosin Scale approved by the American Society for Testing Materials,[4] the French Bordeaux Scale, the Indian Standards Institution,[5] and the Portuguese Standard scale. These are all defined either in terms of CIE chromaticity coordinates or in Lovibond units.

There is also the Paint Research Varnish Colour Scale, devised by the Paint Research Station (Teddington, UK), and defined in terms of Lovibond units. The colours of the components of road marking paints (Rosin, oil, and sand

aggregate) are all specified in a British Standard,[6] as are colours for vitreous enamels.[7]

6.2 DYES, TEXTILES, FABRICS

As with paints, the checking against samples from previous batches is a risky procedure, as samples will change with age and according to the method of storage. Exact records should be kept of every product in terms of meaningful figures.

The matter of colour fastness to light, washing, perspiration and atmospheres is particularly important, and exact data should be recorded on the effects of appropriate testing procedures carried out on representative samples. The Society of Dyers and Colorists (Bradford) and the British Standards Institution[8] issue swatches of standardized textile material which are graduated in terms of colour fastness, and the sample under test may undergo trials alongside these and be reported as having a colour fastness comparable to such and such a grade, but more complete and informative answers come from actual colour measurements. It is helpful to plot the coordinates of the sample colour as it changes under test on a Uniform Chromaticity Scale diagram, as this gives an immediately comprehensible picture as to the degree and direction of change.

For large contracts, specifications as to colour must be agreed and tolerances laid down, as mentioned under Section 6.1. This is especially important here, as different sections of garments and other items of fabric are often made up from different batches, and any variation will be very apparent and lead to rejection of the finished product.

It is not only the exact matching of dyestuffs which requires care. The colour and nature of the substrate itself has a large bearing on the final colour. For example, a less than white wool or cotton will make it difficult to produce a pastel shade or a very bright colour. There is an impressive record of research in the colour grading of raw cotton in the USA, the name of Dorothy Nickerson being particularly associated with this work, from 1931 onwards,[9] which culminated in the development of a photoelectric colour grader using the $L,a,b.$ system of colour differences in 1950.[10] With wool, not only is the base colour important, but also the amount of residual oil, as this will affect the way the dye 'takes'. With all textile materials, the degree of compression of the sample measured will affect the colour, so this must be standardized in some suitable piece of equipment. For wool, it has been suggested that the Z tristimulus value gives the most reliable whiteness index, especially as this is the value least affected by measurement error.[11]

'Optical bleaches', which fluoresce a bluish white when ultraviolet light falls upon them, are much used to whiten materials, and coloured fluorescent dyes are used to produce more saturated and brighter effects. There is enough ultraviolet radiation in daylight to activate this fluorescence, and this was the

reason why illuminant D_{65} was introduced by the CIE in 1971, as this is intended to include the ultraviolet content of daylight, which is absent from illuminants A, B, and C. The colorimetry of such fluorescent samples presents difficulty. The sample must be irradiated by some agreed illuminant which reproduces the conditions under which the goods will eventually be used, and, when it is required to know the extra brightness added, measurements must be made by difference from a non-fluorescent standard of similar colour previously calibrated in a spectrophotometer. (See also pp. 37, 38 and 109.)

Matching to a customer's sample can, as with paint making, be expedited by colour measurements both on the sample and on a trial dyeing on the substrate to be used, as the substrate will greatly affect the result. The fineness of the fibre also has an effect on the final colour, because the finer the fibre the more white light will be reflected from the surface, thus diluting the colour.

Metamerism is a big problem in colour matching unless the actual dyestuffs used to colour a customer's sample are known, and hence the agreement of two samples in terms of $x\,y\,z$ coordinates is no guarantee that the pair is not in fact a metameric match. Only a check from a full spectrophotometric energy distribution curve can finally prove the point, but usually it is sufficient to check sample and standard in two or more illuminants—say Illuminant A, Illuminant C and perhaps natural daylight. This should disclose any discrepancy.

6.3 PLASTICS, LAMINATES

As these are usually made in long runs, and as spare part replacements and additions are often required, the maintenance of a constant colour is very necessary. Records must be kept in terms of colorimetric measurement, and sometimes this is difficult because the samples are small or have irregular or curved surfaces. Most colorimeters are only designed to deal with flat surfaces. Where an integrating sphere is incorporated, this may solve the problem, or a mirror-box may be designed for integrating the colour. The Flexible Optic Tintometer uses a flexible glass-fibre optical lead to collect the colour from the sample, and as the collecting head requires only an area of about 2 mm diameter, this usually solves this problem. A similar system has been adopted for the fibre optics photoelectric colorimeter developed by the Paint Research Association, Teddington, Middlesex.

Fastness of colour against heat and light is an important quality in plastics, and the results of controlled tests for these qualities should be recorded in numerical form. This is usefully displayed as a plot on a Uniform Chromaticity Scale diagram, as suggested in Section 6.2.

One of the criteria for judging the quality of rubber latex is colour, and a special method is laid down for carrying out this test, the colour being described by CIE coordinates.[12] In matching to a customer's sample, time and effort is saved by the use of a colorimeter, and correctly applied this will help to avoid making a metameric match, as mentioned under textiles. This point is especially

important when the plastic article is to be used with some different material, as for example, a plastic buckle or heel for a leather shoe, or a bathroom accessory to match a porcelain wash-basin, where the pigments used for colouring are of necessity different. In the Building Industry, help in standardization of colours for architects is given in various British Standards.[13-15]

6.4 LEATHER

The points previously made regarding paints, dyes and plastics all apply to leather, especially when dealing with coloured leather as opposed to a 'natural' finish. There is often merit in allowing variations in natural leather colour, as this emphasizes the fact that it is a natural product, but where the leather is coloured, as for ladies' handbags or shoes or gloves, the colour must be controlled to match the accessories such as buttons or fasteners or plastic parts. Here the matter of metameric matches is a constant source of trouble, and calls for an understanding of the reasons for the mismatch under varying illuminants.

The colour of tanning extracts has been internationally quoted since 1897,[16-19] this information giving not only a lead to the intensity and colour to be expected in the finished leather, but also to the iron content, which has an important bearing on its behaviour in the tanning process.

6.5. PRINTING AND PAPER MAKING

The reproducibility of the colour of ink is important, even of black ink. There are hundreds of variations possible in the colour of black printing ink as well as of writing ink, and some newspaper and magazine printers maintain a special and particular 'tone' for specific items. To match a particular black without instrumental aid is sometimes the most difficult task facing a colour matcher. During a long run, spot checks are needed to ensure uniformity of whatever colour is being used and a measurement of the ink printed out on the paper to be used will make this check objective.

In large plants, a continuous automatic colour scanning device is often installed which gives warning of colour drift, or even makes corrections for this if it occurs. Often a manufacturer will select a particular shade of colour as a recognizable feature of his packaging, and if more than one printer produces these packs it is obvious that most careful specification and measurement of the colour is necessary. If this is not done, packs from different printers may find themselves side by side on display, and any variation can seriously affect sales. For example, a lighter shade will give the impression that it has faded and that the contents are old, and, if the contents are edible, that they are stale. Not only this, but the impression is given that the manufacturer is careless in quality control, and hence his products are less desirable. Similarly, some traders adopt a coloured trademark, and to create a feeling of reliability it is important that this is invariably and recognizably the same colour. Fastness to light (and

moisture in the case of foodstuffs) is important in inks used for packaging, and for display bills, and careful laboratory tests and measurements should precede the issue of such printed matter. For three-colour reproduction work to match a customer's sample, the need for measurement and recording is obvious, and, in general, the balance between the colours needs rigorous checking, but what is sometimes overlooked is the colour and pH value of the paper as well as its absorbance, gloss, etc. Small variations in whiteness can have a large influence on the colour of the final print and a slow drift can easily happen unless recorded measurements are kept. This is even more true with tinted stock. Some printers rely on the use of a photoelectric photometer to check paper, and even ink: they forget that a photocell has a different response from that of the human eye, and that it measures only total light flux. An off-white yellow and an off-white green could easily record the same light reflection, and yet be demonstrably different colours. Only some suitable form of colorimeter is appropriate for this work.

Tinted-paper making is a field where colour measurement is needed, particularly where it is a running line which is repeated regularly. Retained samples tend to drift, even when kept in the dark, and are a most unreliable guide. A delicately tinted azure paper which is a running line repeated over the years can all too easily drift into a greenish hue if a sample from the last batch is the only check. Unbleached sulphited cellulose pulp has a tendency to redden with age, and a test with hydrogen peroxide will speed this reaction and thus give advance warning of trouble.[20]

The fastness to light of paper and ink is obviously important in most cases, but this is particularly so in map making where colour is used to indicate contours. The exact colour must always be used to indicate height, and this must not change with age. Hence, some ordnance survey authorities issue most rigorous colorimetric specifications for their ink supplies.

Fluorescent inks can cause difficulties. It must be remembered that they can only produce their brilliant colours when viewed by an illuminant containing some ultraviolet light. Tungsten lighting has none, but fluorescent strip-lighting has: special quartz mercury lamps have it in abundance. The ultraviolet content of daylight varies, and the fluorescent effect from a poster is usually most noticeable when the sun is low and the fluorescence is not masked by too much visible illumination. Hence, the ink must be selected for the actual conditions under which it will be viewed. The colorimentry of fluorescent samples is not straightforward, as has already been mentioned (see pp. 37, 38 and 107), and they may be measured by difference against a non-fluorescent sample, while being illuminated by the light in which they will eventually be used.

The standardization of the colour of inks is considered to be so important in the printing trade that there are numerous official standards in existence such as, for example, the following British Standards:

BS 2490 *Waterproof drawing inks;*
BS 2650 *Four-colour offset lithographic inks;*

BS 3020 *Improved inks for letterpress four-colour printing;*
BS 4160 *Inks for letterpress three- or four-colour printing;*
BS 4666 *Inks for offset three- or four-colour printing* (British and European common standard);

which express the colour in terms of chromaticity coordinates, and many such specifications express tolerances in terms of an area on the chromaticity diagram.

The pH of paper is also measured colorimetrically. This information is important because the acidity of the paper influences the drying time of inks, and too acid a paper will cause smudging. The British Standard method[21] involves the extraction of the paper in water and the determination of the pH of the extract, while the PIRA method[22] involves the colour measurement of a smear of indicator solution on a dry surface of the paper sample.

6.6 COSMETIC AND PHARMACEUTICAL INDUSTRIES

The use of colorimentry in the cosmetic industry is obvious: there are so many colours used in lipsticks, eye shadows, nail varnishes and powders, that nothing but careful measurement and record keeping can cope with the situation. Every manufacturer strives to produce recognizably distinctive coloured items, and any drift in colour must be guarded against. This entails the checking of raw materials as well as finished products, and tests for colour fastness in the presence of perspiration and heat must also be carried out. Reversible colour changes occurring during manufacture must be discounted: for example the frictional heat incurred during powder mixing may cause a darkening of colour, which change can usefully be recorded, and allowed for. The colour of material used as a base for cosmetics (e.g. waxes and oils) must be kept to a minimum, and maximum acceptable colours are specified.[23]

The degree of compression of powders has a marked effect on the colour, so thought must be given to the standardized preparation of the sample for measurement.

When it comes to the measurement of the colour of lipstick, a nice problem presents itself. How must the sample be prepared? Shall it be in bulk, spread out on a white tile in a standardized thickness of film using a 'doctor blade', or on the skin of a model? Different operators have different answers. If the skin is chosen, shall it be a blonde, brunette, or coloured model? Anyhow, for a live model, the flexible fibre optic type of colorimeter is the most useful. The same argument applies to sun-tan and screening lotions, while the clinical testing of these is considered in Section 6.12. The colour of the packaging of these products is as important as the contents, and what has been said in Section 6.1 is relevant. In the pharmaceutical field, many products are naturally or artificially coloured, and are recognized by the customer by their colour; variation in colour suggests variation in quality. Some firms have many factories producing the same

product and these products must all be interchangeable in shop displays. This necessitates the strictest control of colour, which is all the customer has to judge by in a shop.

Purity is often judged by absence of colour, and in such cases standards of whiteness or clarity must be laid down and regularly checked to avoid any colour appearing. Many tablets, powders, and capsules are coloured for recognition purposes, and it is important that the colour does not drift from one batch to the next over a period of time, or the point will eventually be reached when two different products can be confused through similarity in colour, and this could be dangerous to the consumer. This coding is used by individual manufacturers for their own products, but there are no recognized national or international colour codings, because the trade considers it safer to rely on labelling.

6.7 ELECTRICAL TRADES

Colour is used for identification purposes in this field, from the negative and positive terminals of an accumulator to the multiple-channel telephone cables with perhaps dozens of colour codes to distinguish the various lines. In case of failure, it is important to know who is the maker of a particular cable, and each manufacturer of cables has his own identification colours as a thread wound in with the cable.[24] The more colours used, the greater the necessity to 'fix' the exact colours to prevent drift over a period, which might easily produce confusion between, say, a yellow and an orange, or an orange and a brown. Hence, specifications must be unequivocal, and as these matters are international, figures are required:[25-28] usually these are stated as CIE coordinates, or are referred to some standard which is so expressed. This need extends beyond wiring identification to the colour of moulded connectors, knobs and plugs, and thus spills over into the plastics trade. Instrument panels have coloured displays to help simplify comprehension, and the coloured lamps and fluorescent words and figures are another place where colorimetric specifications are essential to separate the various areas of colour and to prevent overlapping. Fuses, too, are identified by colour which must be agreed and defined above language difficulties. Signalling by coloured lights is employed for road traffic, railways, airports and aeroplanes, lightbuoys, lighthouses, and ships. All these colours must be agreed in terms of colorimetry to prevent overlapping and hence dangerous misreading of signals. Without such safeguards, a rich orange colour could easily be mistaken for a poor red, and so on. Such specifications are usually prepared in the form of defined areas on the chromaticity diagram.[29, 30] Similar specifications exist for fluorescent paints on buoys, and for road traffic signs.[31]

Illuminated advertising signs in the proximity of traffic signals can cause confusion, and in at least one country there are prohibited areas on the chromaticity diagram from which such signs are barred.[32]

In the field of television, colour measurement plays a large part, even for black and white screens, where the balance of phosphors used must be adjusted to give an agreed white by the additive mixture of radiations. For colour television it is clear that phosphors must conform to rigid specifications in order to produce the best reproduction of pictures. However, some such specifications have tended to be so complicated that they are self defeating and are honoured more in the breach than in the observance, and operators are moving to simpler visual colorimeters, such as the Flexible Optics Tintometer.

For illumination, too, especially for technical purposes, an agreed spectral distribution is required. In this case the chromaticity diagram is not applicable owing to the risk of metameric matches arising, and either a full energy distribution curve or a statement in terms of energy in specified wavelength bands is used, such as in BS 950[33] (incorporating the use of Crawford's six band method[34]) and BS 1853[35] which uses the eight band system.[36] The Commission Internationale de L'Eclairage itself has issued a document on measuring the colour rendering properties of light sources,[37] and the Illuminating Engineering Society has issued reports on specialized lighting requirements.[38, 39] All this use of colour recognition calls for normal colour vision in the people concerned, and hence the various methods of testing colour vision (such as have already been mentioned in Chapter 2) are of particular importance in this field, as mistakes can often have grave consequences.

6.8 FOODS, BEVERAGES, DAIRY PRODUCTS

This field is wide enough for an extensive literature of its own (see, for example, Refs 40–43). Food technologists are interested in the colour of foods because the consumer has highly developed colour preferences, and any food which has an unnatural colour will tend to be rejected. Meat of a bad colour, for example, has little chance of acceptance, and reports have been written on this subject.[44] Butter is commonly coloured by annatto to produce a rich colour,[45] and a number of colour scales are in use for this purpose (e.g. The Milk Marketing Board UK scale, and the special colour standards issued by the Munsell Company).

Colour is the most useful single criterion for judging the maturity of fruits, and hence the significance of colour as a measure of acceptability. Many countries have colour specifications for grading fruit for export,[46] so that the good name of that country shall not be spoilt by the sale of under or overripe fruit. Sometimes insistence on a particular colour for a product is unjustified, but nevertheless the seller must bow to the demand: often a pure orange juice may seem pale, because one has a mental picture of the fruit itself, and customers are only satisfied if some of the peel is used to heighten the colour. Processing may quite legitimately alter the colour of a natural product—for example, canned green peas may become paler or strawberry jam browner than the fresh material—but the manufacturer must restore the colour by whatever means are

at his disposal so that an acceptable colour is maintained over the years. The maintenance of a fixed colour in processed foods is taken by the public as an indication of careful quality control, so that the colorimetry of such items as confectionery, jams, pickles, ketchup, biscuits, mayonnaise, and soft drinks[47] becomes a standard procedure. The Munsell Colour Spinning device described on p. 24 is frequently used for many of these applications. Perhaps the first people in this field of colorimetry were the brewers, who for 100 years have measured the colour of beer[48] so as to maintain uniformity, and today there are international conventions on the subject.[49-53] Similar precautions are taken by distillers, so that proprietary brands may be recognized at once by their colour. Wine growers, too, take great care in the maintenance of a particular colour for a branded wine, and a crop with a rich, full colour is kept for blending with paler vintages in the case of red wines.

Sometimes a food product is sold for its colouring quality, such as paprika or caramel, and here the price is dependent on its measured colour, to standards agreed between buyer and seller.

In some cases it is the absence of colour which is desirable, for instance refined sugar,[54] glucose,[55] lard[56] or flour, and again measurement is employed to keep the colour within an agreed tolerance.

An original application of visual colorimetry in this field was reported by one of the authors,[57] in which tea liquors prepared from different crops were identified by applying Lovibond's Law of Specific Colour Development. The liquors were measured in a Tintometer in a number of different sample thicknesses, and their rate of colour development was plotted in terms of Red Units against Yellow Units. The curves were shown to be specific to each tea estate, so that the place of origin could be clearly identified. This was compared against an alternative procedure using a spectrophotometer and plotting the Log Density Curves, the shape of which are known to be the unique property of the liquid irrespective of sample thickness. It was shown that the visual measurement brought out differences which were difficult to spot by spectrophotometry.

The storage of food is an important area for research in which colour measurement plays a part; oxidation and polymerization of stored food, caused by bad keeping conditions, can often turn colourless constituents into coloured, and such signs of deterioration give early warning of changes which can be studied so that the cause and thence a cure can be found.

Packaging, as previously mentioned in Section 6.5, plays a large part in the food industry, and the colour of labels, packs, tins etc. must be kept closely standardized, particularly when batches produced at different times may find themselves side by side in a shop display. Fried potato chips may sound an unlikely subject for colour maintenance, but this plays an important part in the mass production of part-processed frozen supplies distributed to the trade, so that when finally fried they may look acceptable after a standardized cooking, and the Munsell Company issues printed coloured charts of agreed colours.

Lighting plays a very important part in food displays, as wrong lighting can produce exactly the same visual effect as bad quality in the article, and therefore much control and care is called for in the choice of suitable illuminants, as was discussed in Section 6.7.

6.9 AGRICULTURE AND ALLIED OCCUPATIONS

Agricultural researchers, as well as those who store and process agricultural products, have frequent use for colorimetry.[58] Colour is the most common criterion by which quality and ripeness are judged, as mentioned in Section 6.8, and standards are laid down for many products. Colour charts, such as, for example, those issued by the Munsell Company, are available for grading fruits and vegetables, and the colour of flour grades is specified in many countries. Horticultural charts for identifying, classifying, and grading flowers and foliage are available from many sources (e.g. RHS Colour Chart)[59] and this interest in colour has more than an aesthetic value. For example, colorimetry was involved to define the particular shade of red clover which was found to produce the best breeding stocks for prolific crops of this commodity,[60] and colorimetric methods are used to assay the carotene content of dried fodder.

Research work on soil classification entails keeping records of soil colour on a world-wide scale, and the CIE system was applied to this study by the Rothamsted Research Station.[61]

Charts and spinning top colorimetry are also used in this work. Coloured photographs from aerial surveys of developing countries are employed in this connection to seek suitable soil areas for planting, and for locating diseased crops. The diagnosis of plant diseases and fertilizer deficiencies is largely based on colour changes,[62] and the research laboratory uses a colorimeter for this, while the farmer trusts to his colour memory, until he calls in the expert. In the tobacco growing industry, colour plays a large part in fixing the value of a crop, because the colour indicates smoking quality (yellow to red being the preferred colour) and much has been written on the subject, while automatic photoelectric grading machines are used in some places. At the International Colour Association Congress in 1973 it was reported[63] that great care must be taken with the choice of illumination used in tobacco grading.

Cotton grading is another field in which colour is of vital importance. The monitoring of spray residues on crops is important, and colorimetric chemical methods are used here, as discussed in Section 6.16. The same applies to storage conditions for grain, soil analysis,[64-68] dairying, and veterinary work, e.g. pathology and the checking of pesticide dips,[69] while the study of hydroponics (soilless cultivation using chemical feeding) could not proceed without the use of colorimetric analysis.[70,71] Other products such as honey[72] and maple syrup are graded by colour, and there are numerous colorimetric specifications for these. The most usual methods used are the Pfund wedge-colorimeter, the Munsell charts, or the Lovibond Tintometer.

6.10 OILS, FATS

The marketing of edible oils is based almost entirely on colour, as this gives a positive indication of quality in any given type of oil. In general, it may be said that the paler the colour the higher the quality and the higher the price. The exceptions to this are when there is an 'off colour' in the oil, indicating (in vegetable oils) a bad growing season or some adulteration, or where an oil has been artificially bleached: in this case, the expert has means other than the direct colour to identify this. Pale colour in vegetable oils usually indicates the first pressing and a blander flavour, but also the buyer will pay a higher price because he will not have to decolorize the oil before using it. Throughout the world, whale oil is valued on its Lovibond colour rating,[73] the darker the colour the lower the price. The same applies to fish oils, such as herring.

Vegetable oils are similarly rated, and in most countries the system of the American Oil Chemists Society is followed,[74] using a depth of 5¼ inches of sample and the specially calibrated N″ (pronounced N double prime) Lovibond scale approved by the Bureau of Standards (Washington DC). The reason for using this strange depth of sample (5¼ inches or 133 mm) is historical, this being the height of the sample bottles originally used, and the colour was judged looking down the length of the bottle. The colours are so well known and memorized that, in the trade, the limiting colour, of, for example, 'prime cotton seed oil; 7.6 Red, 35.0 Yellow Lovibond', can be recognized at once by the expert.

There are other specifications for required colour standards, such as those approved by British, Egyptian, German, Indian, Japanese, Spanish and South American Standards Institutions for vegetable oils, and most of these are expressed in terms of Lovibond Red and Yellow units. The Fats Analysis Committee of the American Oil Chemists Society has authorized a colour scale for the various grades of animal fats, defined in terms of Lovibond units,[75] and this is used in many different countries.

Other colour scales used for edible oils are the Gardner Scale[76] and the Hazen[77] (or American Public Health Association scale or chloroplatinate cobaltous chloride scale), both of which define the colours in terms of CIE chromaticity coordinates.

The well-known 'Kreiss' test[78] for incipient rancidity of oils and fats is a colorimetric one, and is still widely used.

In the field of petroleum oils, colour again is important as it gives information as to the degree of refining, and there are a number of scales in use. Perhaps the most widely used is the ASTM D1500 scale[79] for lubricating oils, heating oils, and diesel fuel oils and this has been adopted in many countries. This uses a sample depth of 33 mm, and the colours are defined as CIE coordinates for the 16 grades. Refined Petroleum products are usually graded for colour on the Institute of Petroleum Scale[80] (defined in terms of Lovibond Units) or photoelectrically to CIE coordinates, or in terms of the Saybolt visual colorimeter, which measures the height of the column of the sample liquid required to match fixed glass colour standards.

The degree of refining of lower boiling products of coal tar, such as benzoles, is assessed colorimetrically by means of the Acid Wash test[81] using sulphuric acid.

6.11 ENVIRONMENTAL HAZARDS CONTROL

In industrial premises, many dangerous hazards are signalled by colour codes. Examples of this are cylinders of compressed gases;[82] service pipes conveying different liquids and gases;[83,84] compressed air, or vacuum, plastic pipelines required to withstand high internal pressures;[85] the use of the wrong type of metal in piping systems (which has been shown to lead to failures in process plant);[86] high voltage cables; and steam under pressure. These must be easily and clearly distinguished, and the colours and codes must be exactly defined to prevent any misunderstanding. Hence many Standardizing and Governmental bodies issue colour specifications for the above, and also for colours used to mark dangerous chemicals, hazardous machinery, fire assembly points and fire fighting equipment,[87] and danger points such as theatre exits.[88] These specifications usually refer to colours in other standards, such as colour charts or paint standards, which are themselves expressed in figures from some appropriate system.

6.12 MEDICINE AND PUBLIC HEALTH

In connection with plastic surgery and the fashioning of plastic parts for prostheses, workers have been enabled to save patients much attendance time and trouble by making careful measurements of the colour of adjacent skin areas, so that the artificial part may be coloured to match without the constant attendance of the patient.[89] Similarly, in the making of dentures the new teeth may be matched to the colour of the patient's own without the need for his physical presence. Reports have been published on tolerance to deep X-ray therapy by measurement of the colour produced in erythema of the patient's skin.[90,91] Loss of pigmentation in African patients suffering from tuberculosis has been used as an aid to the clinical diagnosis of this disease.[92]

The likelihood of rejection of skin grafts can be foretold by minute recorded changes in the colour of the graft. Changes in the pigmentation of skin and hair under adverse climatic conditions have been studied and recorded colorimetrically, and much work has been done on the comparative effectiveness of sun-screening lotions using suitably designed colorimeters. The colour and composition of the illumination used for diagnosis in hospitals and dental surgeries is increasingly being studied and specified, as it is realized that very slight abnormalities in lighting can affect conclusions reached in the operating theatre;[93] unless the lighting is of the right composition, the anaesthetist cannot form an accurate opinion as to the patient's condition.[94] The colour coding of gas cylinders used for anaesthesia is standardized for safety's sake.[95] The testing

of colour-vision defects comes under this heading, and the equipment used has already been described. Pathology depends very much on colorimetry, and this is dealt with under Section 6.16.2.

6.13 BIOLOGY AND NATURAL HISTORY, MINERALOGY AND GEOLOGY

The recording of the colour of skin, fur, and feathers and the changes which take place seasonally, with climatic changes, and with age, are an important aspect of this work. In the field this is mostly done from colour charts, but these must be related colorimetrically to something more permanent, and this will usually lead to plotting on the chromaticity diagram. The keeping of specimens of such material in a museum is unsatisfactory from the colour point of view, as this will change where pigmentation is involved, so records of original colour are required. The colours caused by diffraction, such as with beetle's wings, some butterflies, and some feathers, are almost impossible to measure, as they change with viewing angle: but as the colour is caused by the configuration of the material this is fortunately not of an ephemeral nature.[96]

Some very interesting work has been done on heredity in plumage colours in various subspecies: it was shown by colorimetric measurements and records, for example, in the bird sanctuary at Fair Isle that recognizable subdivisions of seagulls from quite small geographical areas could be identified by colour.[97] The same kind of local identity can be found in many birds and insects.

In the field of mineralogy, there are a number of colour charts published (such as those by Munsell) for recording the colour of rocks and soils in surveys; while the identification of ores may be established from a study of colour and hardness. The colour gamut of precious and semi-precious stones is so wide that measurement rather than description is needed. With cut and polished stones there are difficulties, partly because they are usually too small for a conventional colorimeter to handle, and partly owing to the complications of illumination without multiple reflections. This is a situation where the human eye plus brain is an unbeatable combination, because it can 'make allowances' and ignore what it does not want to see. Although many ingenious photoelectric devices have been designed for these problems, this is a field where the expert is still best served by his natural senses, and these can be reinforced by a colour comparison microscope.

6.14 FORENSIC SCIENCE

There is, in this field, constant need for comparison of colours to establish identity between two parts, and as the difference between identity and non-identity may be very small, great care and accuracy must be used to convince a court. Usually the samples are small—such as a hair, a thread of cloth, or a chip of paint—so special apparatus is needed. For straight comparison a 'comparison

microscope' with two fields is used, but when the colour as seen in the instrument must be recorded, a specialized colorimeter is used. One such, employing Lovibond glasses, was described by Osborn in 1910[98] and this was modified by Haselden in 1935,[99] and Harrison in 1958.[100]

This procedure has been applied to the detection of forgeries in documents, by showing up the difference in colours of inks in different parts of a document,[101] whether handwritten or typed, but even if an addition or alteration has been made with the same ink at a later time this will show and be recorded, because the colour changes at a regular pace as a result of atmospheric oxidation.[102]

Picture galleries have used colorimetric methods of varying elaboration to record the fading of pictures through injudicious lighting, to chart the progress of cleaning and restoration, to check whether pictures on loan have suffered during their absence from their home base, and also in some cases to check the authenticity of an attribution, where the artist was known to use a particular colour habitually.[103–107]

An interesting application in police work is in the confirmation that a particular paint chip came from a particular car, or even to identify the make of car from which a chip originated. Individual makers have a standardized procedure of a number of fillers, undercoats, and top coats, and a microscopical examination of a cross-section of the strata, with a measurement of their colours, can identify the make, as well as pinning it to an individual car if an authenticated sample is available for similar examination.

The same kind of microscopical examination can yield much information on paper, fabrics and laminates.

6.15 PHOTOGRAPHY

The application of colorimetry to the development of new processes and materials in this field is so important that many of the best known contributions to the science of colour measurement have come from this industry. In any bibliography of work on colour science the names of MacAdam, Hunt, Kowaliski, Spencer, and Ralph Evans are certain to feature, and these all come from this industry. Indeed, many people know the name of Maxwell because of his early work on colour photography.

Colour measurement is involved in photography in the development of new procedures, in the assessment of the performance of materials and processes, in the choice of viewing conditions and illumination, and in the control of packaging and presentation.

One point of interest is that it is not reasonable to rely on colour photographs as an exact record of the colour of objects. The manufacturers themselves are quite frank in saying that they do not claim exact reproduction of the colour of the object photographed, quite apart from the fact that colour photographs fade. The reason is one of sheer economics: the degree of control of materials

and processing, to say nothing of the control of the photographer himself, would make the cost of obtaining exact and true reproductions entirely prohibitive. What is claimed is a pleasing result which will be acceptable to most people most of the time, and this in fact is what is achieved.

6.16 COLORIMETRIC CHEMICAL ANALYSIS

The analytical chemist has many different tools and methods at his disposal, gravimetric, polarimetric, electrophoretic, mass spectrometric and others, but the most used and useful is the colorimetric method. A specialized branch of this is flame photometry, mostly used for the alkali metal elements of which the commonest are sodium, potassium and lithium and the alkaline earth metals such as calcium. In this procedure, the element is isolated chemically, a solution of it is vaporized and blown through a hot flame, when a specifically coloured flame is produced. This flame is examined in a specially adapted spectrophotometer previously calibrated, and the intensity of colour is recorded as proportional to concentration.

What is most generally understood by the term colorimetric chemistry, however, is the comparison of coloured solutions. Nearly every chemical element is able, under appropriate treatment, to combine with some reagent to form a coloured radical, the colour of which, under the special conditions laid down, is specific to that element, and the intensity (or saturation) of the colour is proportional to the concentration of the solution. The skill of the chemist consists of finding some chemical reagent which will combine with that element to form a coloured compound, and the conditions under which such a colour is specific. As several other substances present may unfortunately react to form the same colour, the chemist also has frequently to carry out a preliminary chemical separation so that only the element under discussion can react without interference. The procedure therefore varies a great deal, and may be a very simple one or very complicated and lengthy. Once having produced this

Fig. 6.1. Comparator employing Walpole principle.

coloured solution, the 'metric' part consists of assessing the concentration by a comparison of the colour saturation against that of solutions of known concentrations similarly prepared. This may be done from first principles by actually preparing a series of such solutions of varying concentration, or by using synthetic solutions of the same colour which may be prepared more easily and are more permanent, or by using colour standards of glass which have been carefully matched under stated conditions of illumination against the chemical solutions, or even in some simple tests printed colour cards are used. Of all these methods, the most reliable is the use of glass standards which are absolutely permanent in colour, and because of their permanence can be checked and cross-checked before being put into use. In all the above cases, a suitable piece of apparatus is employed to hold sample and standard so that they are compared under fixed viewing conditions. Such a piece of apparatus is called a Comparator, and by employing the Walpole principle of compensation (original solution plus colour standard compared against colour-developed solution plus solvent—see Fig. 6.1) even coloured sample solutions can be compared satisfactorily.

This method of direct comparison is the simplest and cheapest, and is especially appropriate for field work, or in a laboratory not equipped with more sophisticated apparatus. Examples of such commercial Comparators are the Lovibond Comparator (Fig. 6.2) in England and the Hellige Comparator of Germany and the USA.

Fig. 6.2. The Lovibond comparator.

Alternatively, the instrumental approach to this last stage in colorimetric analysis is either by a filter colorimeter or a spectrophotometer. Photoelectric colorimeters for chemical analysis employ a series of colour filters of gelatine or glass which are interposed between a source of illumination and the solution (held in a glass cell of appropriate depth), a photocell to be activated by the emergent light, and a galvanometer to record the intensity of the light (the light flux). The filter is selected to be the complementary colour to the solution, so that the emergent light is approximately achromatic, and the cell is asked to record only intensity of light (being relatively colour blind) at the point of maximum absorption of the solution. The galvanometer readings are calibrated against standards of known concentration, so that the answer may be read in parts per million of the particular radical under consideration. The name colorimeter is obviously a misnomer, because total light flux and not colour is being measured: however, the name is universally adopted. Provided that the apparatus is properly and carefully used, that the correct filter is in position, that the glass cells are scrupulously clean and free from dirt and finger marks, and that proper precautions are taken to maintain the colour temperature of the lamp and to prevent fatigue or heating of the photocell, this method has many advantages. Examples of such instruments are the EEL range of colorimeters, made by the Evans Electroselenium Company, and the Spekker absorptiometer which was made by Hilger Ltd, and is now made in some other countries under licence.

Spectrophotometers are also used for such work in large laboratories, but as a reading is required at only one wavelength (i.e. at the point of maximum absorption of the coloured solution), this is an unnecessarily complex and delicate instrument for most purposes. However, in research on a new reaction it is clearly desirable to know the full transmission curve, so that the appropriate point of maximum absorption may be selected at which to prepare a calibration graph against concentration. In certain organic chemical analyses, where the peak absorption occurs in the ultraviolet or infrared region (and the test is therefore not colorimetric at all), a spectrophotometer is essential. Nevertheless, it is a comment on the instrument-oriented outlook of chemists that the majority of spectrophotometers sold are for 'colorimetric' chemical analysis and not for the true measurement of colour for which they are designed.

One very simple precaution which is often omitted is to *look* at the solution before submitting it to the photocell. If anything has gone wrong in the chemical procedure, then the solution may be 'off colour' or turbid, but the photocell (which merely measures total light flux) will still give an answer, although hopelessly wrong: yet some operators become so automatic that they omit this inspection. This is where a visual method of comparison has an advantage. If something is wrong, it will be impossible to obtain a match to the standards, and hence one is put 'on enquiry'.

It is a wise precaution when using instrumental methods, to run a complete spectral distribution curve at intervals, on one of the samples, to check that the

colour is running true to form, and to put in a known standard solution at intervals to check that the calibration remains correct. In many advanced instruments the filling of the cells with test sample, positioning, recording the result, and washing out the cells, is automated. This is only an economic proposition when large numbers of the same test are being run.

Examples of the kind of chemical tests carried out by colorimetric procedures may be considered under many headings, of which the following are representative.

6.16.1 Food and dairying

Analytical control in this sphere is of great importance, not only because of potential risks to health if food is contaminated, but because legislation in many countries controls the purity of foods and the extent of permitted additives such as preservatives and colouring. Contamination by handling, by air-borne germs, or by oxidative spoilage is outside the scope of colorimetric chemistry and is a matter for the bacteriologist, but metallic or chemical contamination can be equally dangerous, and comes within the orbit of 'colorimetric analysis'. Examples are lead in beer; copper in various beverages and milk, picked up from processing vessels; or cadmium sometimes used in paints which might come in contact with edible materials; arsenic is sometimes found in gelatine, and is naturally present in harmless amounts in some shell-fish; mercury used as seed-dressing may be washed from agricultural land into rivers and lakes and be found finally in fish. Preservatives such as sulphur dioxide in canned vegetables or nitrite in pickled meats are subject to a legal maximum. Penicillin injected by a veterinary surgeon into a cow for medical reasons may appear in the milk if sufficient time has not been allowed for elimination, and this can induce an unwanted reaction in a consumer.[108] A colorimetric test is available for penicillin, and all other items mentioned are dealt with in all standard analytical text books dealing with colorimetric chemistry.

Other colorimetric chemical tests used in the dairy are a check on the correct pasteurization of milk,[109,110] and an assessment of the hygienic quality of milk in reference to mastitis in the cow.[111,112]

In the potato crisp industry, the reducing-sugar content of the potatoes has a direct bearing on the suitability of the product for processing, and the Potato Chip Institute of America has laid down a colorimetric method for ascertaining the percentage reducing-sugar content of a representative sample.

Storage conditions for flour and other foodstuffs must be controlled for temperature and humidity, and a colorimetric method is widely used for measuring humidity under such conditions.[113-115] This method utilizes prepared test papers impregnated with cobalt thiocyanate, which change colour with variations in humidity. Fats which are rancid are inedible, and a colorimetric test which gives early warning of incipient rancidity is a valuable tool in supervision as well as a yardstick for Public Health Authorities to use in

disputed cases.[78]

Another source of danger in foodstuffs is that of poisonous residues left on food crops after spraying with insecticides, and many colorimetric chemical tests are available for this work.[116] On the plus side, where one is assessing good quality and not defects, the determination of vitamin A and C content of foodstuffs and animal feeds may be performed by colorimetric methods.

6.16.2 Public health and medicine

The monitoring of water supplies against contamination, such as from factory effluents and farmyard drainage, and the tracking down of such sources to their origin, is a well used area for colorimetric chemical tests, and the control of additives such as fluoride and chlorine to drinking water is another field.

Perhaps the tests of this kind best known to the public are those used on swimming pool water to test the pH (acidity or alkalinity) by means of 'indicators' which change colour at different pH levels, and the test for chlorine concentration by means of DPD (diethyl p-phenylenediamine) tablets, which produce increasing depth of colour with increasing dosages of chlorine.[117]

Atmospheric pollution is monitored by drawing a known volume of the air through a liquid reagent or a prepared sensitized paper, and comparing the colour produced against colour standards which represent differing concentrations, so that a quantitative result is obtained.[118,119]

In some parts of the world, rivers carry water-borne diseases, or are the home of carriers, such as the snails which are intermediate hosts to the scourge bilharziasis, and the method of fighting such diseases is to dose the rivers with a suitable killing chemical. It is essential, however, to monitor the dosage very carefully to ensure that it is below the toxicity level for man or animals or fish. In the case of bilharzia, the chemical N-trityl-morpholine is fatal to the snails at a dosage of 1 part in 20 million parts of water, but at this level is harmless to other users of the river. The control of the level of dosage and residual is by a colorimetric chemical test. Again, in the use of organophosphorus pesticides for crop spraying from aeroplanes for pest control on a large scale, there is a measure of danger to operators, and the medical officer in charge must carry out frequent blood tests, so that anyone affected may be treated at once, and a simple colorimetric test is used.[120]

For the ecological surveying of rivers and lakes, many of these colorimetric tests are needed which have been mentioned previously, such as the presence of metals, plus tests for nitrates, nitrites and sulphates, and chemical oxygen demand,[121] and even the hardness of the water can be determined colorimetrically, using eriochrome as a colour indicator.[122]

In medicine there is a wide field for colorimetric chemical analysis in the Toxicological Laboratory, and a very large proportion of this work is done by these means. For example, bilirubin, cholesterol, haemoglobin, phosphate, protein, sugar, urea and uric acid in blood are every-day routine tests. In a large

hospital there will be found very sophisticated automatic equipment for this work, while at the other end of the scale a medical assistant may have to work in an isolated post in the bush with the simplest possible tools, but all will be using colour measurement of some kind in the final assessment.[123–126]

6.16.3 Agriculture and industry

The testing of soils and of the plant tissues themselves for mineral deficiencies has already been mentioned on p. 114, but colorimetry in the sense of colorimetric chemistry also touches agriculture through the pathological tests of the veterinary surgeon, the checking of sheep and cattle dips, and the measurement of the carotene content of grass meal for poultry feed.

In the sphere of industry, colorimetric chemical methods provide the means of checking processes, from the testing of petroleum oils during refining, the bleaching and proofing of paper and textiles and the monitoring of additives in boiler water, to the analysis of metals and the assay of geological specimens.

6.16.4 Summary

The devising of colorimetric chemical methods of analysis and control in all branches of human activity is a continuing process, and is the subject of a complete literature of its own, as is indicated by a brief selection of such books in the bibliography.[127–132]

REFERENCES

1. See for example: British Standard BS 381C *Colours for specific purposes* and Supplement No. 1 *Table of colorimetric values*, PD 5824, BSI, London, 1966.
2. Canadian Government Specifications Board, 1-GP series, *Pigments and Varnishes*.
3. Eire. Standard Specifications, 1.5.32 *Paints and Enamels*, 1.5.10 *Varnish*.
4. American Society for Testing Materials (Philadelphia), Standard D509, *Naval Stores, Rosin*.
5. Indian Standards Institution (New Delhi), Standard 553, *Rosin*.
6. British Standard BS 3262, *Road Marking Materials*, BSI, London.
7. British Standard BS 4900, *Colours for Vitreous Enamels*, BSI, London.
8. British Standard, BS 1006, Reference Standards Nos. 1–8, *Methods for the determination of the colour fastness of textiles to light*, BSI, London.
9. D. Nickerson, A colorimeter for use with disc mixture, *J. Opt. Soc. Am.* **21**, 640 (1931).
10. D. Nickerson, R. Hunter and M.G. Powell, New automatic colorimeter for cotton, *J. Opt. Soc. Am.* **40**, 446 (1950).
11. E. Coates, M. G. King and B. Rigg, The Whiteness of Wool, *Colour 73* (Report of 2nd Congress of The International Colour Assn), Adam Hilger, London, 1973, p. 447.
12. British Standard BS 1672, Part 2 Amendment 3, *Methods of testing natural rubber latices*, BSI, London.
13. British Standard BS 4901, *Colours for Plastics*, BSI, London.
14. British Standard BS 4902, *Colours for sheet and tile flooring*, BSI, London.
15. British Standard BS 5252, *Colour co-ordination for architectural use*, BSI, London.

16. International Society of Leather Trades Chemists, Standard method of Colour Measurement of Tanning Materials, *Proceedings of First International Conference,* London, 1897, p. 113.
17. Above method (Ref. 16) confirmed at the Vienna Congress 1898.
18. International Society of Leather Trades Chemists, Standard Method of Colour Measurement of Tanning Materials, *Official Methods of Analysis,* 1938, p. 20.
19. International Society Leather Trades Chemists, *Provisional Official method of the British Section for the Colour Measurement of Tanning Solutions,* 1942.
20. Finnish Paper and Pulp Standard A.2011, A.B. Centrallaboratorium, Helsinki.
21. British Standard BS 2924, *Methods for the determination of pH value . . . of aqueous extracts of paper and board,* BSI, London.
22. G. J. Chamberlin and R. R. Coupe, Testing the surface pH of paper, *Print. Technol. (London)* **6**, 7 (1962).
23. USA Toilet Goods Association Inc., Board of Standards Specifications.
24. British Standard PD 2379 and Amendment PD 6135, *Register of colours of manufacturers identification threads for electrical cables* (colour combinations allocated to cable manufacturers in British Commonwealth and South Africa), BSI, London.
25. British Standard BS 1843, *Colour code for twin compensating cables for thermocouples,* BSI, London.
26. British Standard AU7, *Chart and colour code for vehicle wiring,* BSI, London.
27. British Standard BS 4410, *Connection of flexible cables and cords to appliances,* Also Amendment AMD262, BSI, London.
28. British Standards BS 6746, *PVC insulation and sheath of electric cables,* BSI, London.
29. British Standard BS 1376, *Colours of light signals,* BSI, London.
30. British Standard BS 3224, *Lighting fittings for civil land aerodromes,* BSI, London.
31. British Standard BS 873, *The construction of road traffic signs and internally illuminated bollards,* BSI, London.
32. D. M. Finch and J. Howard, 'A color comparator for lights in the vicinity of traffic signals'. Paper presented to the 37th Annual meeting of the Highways Research Board, Washington DC, 1958.
33. British Standard BS 950 Part I, *Illuminant for colour matching and colour appraisal,* BSI, London.
34. B. H. Crawford, The colour rendering properties of illuminants: the application of psychophysical measurement to their evaluation, *Br. J. Appl. Phys.* **14**, 319 (1963).
35. British Standard BS 1853, *Tubular fluorescent lamps for general lighting service,* BSI, London.
36. P. J. Bouma, Colour reproduction in the use of different sources of 'white light,' *Philips Tech. Rev.* **2**, 1 (1937).
37. CIE Publication, N. 13.2, *Method of measuring and specifying colour rendering properties of light source,* 2nd Edn, CIE, Paris, 1974.
38. IES Techinical Report, No. 12, *Hospital Lighting,* 1968.
39. IES Technical Report, No. 14, *Lighting of art galleries and museums,* 1970.
40. G. Mackinney and Angela Little, *Color of foods,* Avi Publishing, Westport, Connecticut, 1962.
41. P. Goose and R. Binsted, *Tomato paste, puree, juice and powder,* Food Trade Press, London, 1964.
42. G. J. Chamberlin, Colorimetry and Foodstuffs in Britain, *Color in Foods,* A symposium by the Advisory Board on Quartermaster Research, National Academy of Sciences, Washington DC, 1954, p. 23.
43. G. J. Chamberlin, Kippers, Cocktails, Confectionery and Colours, *Farbe* **6**, 133 (1957).

44. D. B. MacDougall, Characteristics of the appearance of meat, *J. Sci. Food Agric.* **22**, 427 (1971).
45. South African Bureau of Standards, SABS 519–1950, *Annatto for food products.* British Standard BS 2450, *Annatto,* BSI, London.
46. *Quality Standards for Pineapple,* Dept. of Agriculture, Canning Research Station, Johore, Malaya.
47. *Series of specifications on fruit juices,* Instituto Nacional de Investigaciones Tecnologicas y Normalizacion, Chile.
48. J. W. Lovibond, On the scientific measurement of colour in beer, *J. Fed. Inst. Brew.* **111**(5), 405 (1897).
49. L. R. Bishop, Proposed revision of the Lovibond 52 Series of glass slides, *J. Inst. Brew.* **36**, 373 (1950).
50. L. R. Bishop, Standard methods of analysis. Revision of method of colour determination, *J. Inst. Brew.* **49**, 247 (1952).
51. L. R. Bishop, Revised recommendation for the measurement of colour of worts and beers, *J. Inst. Brew.* **71**, 471 (1965).
52. Analysis Committee of the European Brewery Convention, Colour of barley and malt: Methods of Analysis, *Analytica,* 304E (1953).
53. Analysis Committee of the European Brewery Convention, Colour of Caramel and roasted malts: Methods of Analysis, *Analytica,* 2–400E (1958).
54. *Testing of colour of sugar crystals,* Ministry of Economy, Mexico.
55. Indian Standards Institution, IS 873 Amendment 1, *Colour of liquid glucose.*
56. Trade Standard for lard, Denmark.
57. G. J. Chamberlin, What use is Colorimetry?, *J. Colour Group* (GB) No. 16, 214 (1972).
58. D. Nickerson, Colour measurement and its application to the grading of agricultural products, *US Dep. Agric. Misc. Publ.* 580 (1946).
59. *Royal Horticultural Society Colour Chart,* London, 1966.
60. R. P. Hawkins, Clover colours. Investigations on local strains of herbage plants, *J. Br. Grassl. Soc.* **9**, 221 (1954).
61. R. K. Schofield, The representation of soil colour by means of the CIE coordinates, *Trans. 1st Commission Internal Soc. Soil Sci.,* Vol. A, 1938.
62. T. Wallace, *The diagnosis of mineral deficiencies in plants by visual symptoms,* HMSO, London, 1951.
63. T. Kehlibarov and B. Atanasov, On the choice of illumination for . . . colours in the grading of tobacco leaves, *Colour 73* (Report of 2nd Congress of the International Colour Association), Adam Hilger, London, 1973, p. 544.
64. D. Gilchrist. Shirlaw, *Soil fertility and field methods of analysis,* Cassell, London, 1962.
65. D. J. D. Nicholas and J. O. Jones, The application of rapid chemical tests to plant tissues, *Long Ashton Research Station. (Bristol) Annual Report,* 1944.
66. W. Plant, J. O. Jones and D. J. D. Nicholas, The technique of chemical tissue tests, *Long Ashton Research Station (Bristol) Annual Report,* 1944.
67. D. J. D. Nicholas, *Chemical Tissue Tests for determining the mineral status of plants in the field,* Tintometer Ltd, Salisbury, 1953.
68. E. B. Kidson, Cobalt content of N.Z. soils, *N.Z. J. Sci. Technol.* **18**, 601 (1936).
69. R. B. Delves, M. A. Pinnegar and B. P. Fox, Rapid field tests of strength of animal dip wash tanks, *P.A.N.S.* **17**, 378 (1971).
70. G. S. Fawcett and R. H. Stoughton, *The Chemical Testing of Plant Nutrient Solutions,* Tintometer Ltd., Salisbury, 1944.
71. R. H. Stoughton, *Soilless cultivation and its application to commercial crop production,* Food and Agriculture Organisation, Rome, 1966.

72. Commonwealth Food Specification 8–3–10, *Honey, Australia*.
73. Norsk Standard 489 *Whale Oil*, Norway.
74. American Oil Chemists' Society, Method Cc 13b–45, Revision of 1962.
75. Fats Analysis Committee of the American Oil Chemists Society method Cc 13a–64.
76. *Gardner Scale*, American Society for Testing Materials D1544–63T. American Oil Chemists Society Method Td 1A–64.
77. *Hazen color scale*, American Society for Testing Materials D1045–58, and D1209–62. British Standard BS 2690:1970 Part 9.
78. C. H. Lea, *Rancidity in edible fats*, D.S.I.R. Food Investigation Board, Special Report 48, HMSO, London, 1938.
79. *Lubricating oil scale*, American Society for Testing Materials, Method D1500–64. Institute of Petroleum (London) method, 196–66. International Standards Organisation, Test 2049–1972.
80. *Refined petroleum products scale*, Institute of Petroleum (London) Test 17.
81. Standardisation of Tar Products Test Committee, *Standard Methods for Testing Tar*, 6th Edn, Acid Wash Test RLB 10, Leeds, 1967.
82. British Standard BS 349 *Identification of contents of industrial gas containers*, BSI, London.
83. International Standards Organisation, R508–1966, *Identification of colours for pipes conveying fluids in liquid or gaseous condition in land installations and on board ships*.
84. British Standard BS 1710, *Identification of pipelines*, BSI, London.
85. British Standard BS 4159, *Colour markings of plastic pipes to indicate pressure ratings*, BSI, London.
86. British Standard BS 5383, *Materials for metal pipes and piping systems*, BSI, London.
87. British Standard BS DD48, *Identification of fire extinguishers*, BSI, London.
88. British Standard BS 2560, *Exit signs for cinemas, theatres, and places of public entertainment*, BSI, London.
89. G. J. Chamberlin and B. Jolles, Measurement of colour of skin, in *Methods in microcirculation studies*, H. K. Lewis, London, 1972, p. 18.
90. B. Jolles and R. G. Harrison, Enzymic processes and vascular changes with skin radiation reaction, *Br. J. Radiol.* **39**, 12 (1966).
91. B. Jolles, Colorimetric study of radiation induced inflammatory changes in skin, in *Methods in microcirculation studies*, H. K. Lewis, London, 1972, p. 28.
92. C. A. Pearson, Hypochromia as a clinical sign of tuberculosis in the tropics, *Tubercle* **59**, 111 (1978).
93. A. Garrett, Diagnostic colour from . . . light in dental hospitals, *Colour 73* (Report of 2nd Congress of the International Colour Association) Adam Hilger, London, 1973, p. 370.
94. B. R. P. Murray and H. P. B. Whitty, The apparent skin colour of unconscious patients in relation to the source of illumination, *Anaesthesia* **20**, 123 (1965).
95. British Standard BS 1319, *Medical gas cylinders and anaesthetic apparatus*, BSI, London.
96. W. D. Wright, *The rays are not coloured*, Adam Hilger, London, 1967, pp. 7–16.
97. *First Annual Report*, Fair Isle Bird Observatory, 1949, p. 22.
98. A. S. Osborn, *Questioned Documents*, The Lawyers Co-Operative Publishing Co., Rochester NY, 1910, p. 355 etc.
99. R. B. Haselden, *Scientific aids for the study of manuscripts*, Bibliographical Society, 1935, pp. 52–54, 89.
100. W. R. Harrison, *Suspect Documents*, Sweet and Maxwell, London, 1958, pp. 76, 132.

101. R. B. Altick, Forgeries and alterations to manuscripts, in *The Scholar Adventurers,* Macmillan Co., New York, 1950, p. 195.
102. Mitchell C. Ainsworth, Age of ink on documents, *Analyst* **33**, 80 (1908).
103. F. I. G. Rawlins, Studies in the colorimetry of paintings, Part 1, *Tech. Stud. (USA)* **IV**, 179 (1936).
104. F. I. G. Rawlins, Studies in the colorimetry of paintings, Part 2, *Tech. Stud. (USA)* **V**, 150 (1937).
105. F. I. G. Rawlins, Studies in the colorimetry of paintings, Part 3, *Tech. Stud. (USA)* **IX**, 207 (1941).
106. F. I. G. Rawlins, The physics and chemistry of paintings, The Royal Society of Arts Cantor Lecture, London, 1937.
107. Anon., An exhibition of cleaned pictures 1936–1947, Handbook of exhibition, The National Gallery, London, 1947.
108. R. C. Wright and J. Tramer, Detection of penicillin in milk, *J. Soc. Dairy Technol.* **14**, 85 (1961).
109. R. Aschaffenburg and J. E. C. Mullen, A new test for pasteurisation of milk, *J. Dairy Res.* **16**, 58 (1949).
110. Controle des laits crus et pasteurises, *Journal Official de la Republic Francaise* No. 1037, 28 (1955).
111. Statutory Instrument 1960, 1542, *Milk (Special Designations) Regulations,* HMSO, London, 1960.
112. British Standard BS 4285:1968, *Methods of microbiological examinations for dairy purposes,* BSI, London.
113. M. E. Solomon, A colorimetric humidity test, *Ann. Appl. Biol.* **32**, 75 (1945).
114. M. E. Solomon, A colorimetric humidity test, *Ann. Appl. Biol.* **42**, 543 (1951).
115. M. E. Solomon, The estimation of humidity with cobalt thiocyanate papers, *Bull. Entomol. Res.* **48**, 489 (1957).
116. S. H. Yuen, The determination of benzene hexachloride residues, *Analyst* **89**, 726 (1964).
117. British Standard BS 1427: 1962 Amendment 3.1968 *Routine control methods of testing water used in industry,* BSI, London.
118. R. B. Sharp, Tests for carbon dioxide in atmospheres, *J. Agric. Eng. Res.* **9**, 87 (1964).
119. Department of Employment, *Methods for the detection of toxic substances in air,* continuing series of booklets issued by HMSO, London.
120. E. D. Edson, Monitoring the blood levels of spray operators using organophosphorus insecticides, *Br. Med. J.* **i**, 841 (1955).
121. Ministry of Technology, *Notes on Water Pollution No. 44—Simple methods for testing sewage effluents,* Water Pollution Research Laboratory 1969, p. 4.
122. A. T. Palin, Colorimetric determination of water hardness, *Water & Water Eng.* **71**, 109 (1967).
123. I. D. P. Wootton, *Microanalysis in Medical Biochemistry,* 4th Edn, J. & A. Churchill, London, 1964.
124. D. Stansfield, *Simple tests for medical laboratories,* Tintometer Ltd, Salisbury, 1972.
125. G. J. Chamberlin, *Colour Measurement and Public Health,* Tintometer Ltd, Salisbury, 1967.
126. E. Berman, *Toxic Metals and their Analysis,* Heyden, London, 1980.
127. F. D. Snell, C. T. Snell and C. A. Snell, *Colorimetric Methods of Analysis,* D. Van Nostrand Co, New York, New Jersey, and London, 1959.
128. A. I. Vogel, *A text book of quantitative inorganic analysis,* 3rd Edn, Longmans, London, 1961.

129. American Public Health Association, *Standard Methods for the examination of water and waste water*, 13th Edn, APHA, Washington DC, 1971.
130. L. Klein, *River Pollution, Part 1, Chemical Analysis*, 6th impression, Butterworth, London, 1971.
131. L. C. Thomas and G. J. Chamberlin, *Colorimetric Chemical Analytical Methods*, 9th Edn, Tintometer Ltd, Salisbury, 1980.
132. E. B. Sandell, *Colorimetric Determination of Traces of Metals*, Wiley-Interscience, New York, 1959.

BOOKS ON GENERAL COLOUR SCIENCE FOR FURTHER STUDY

F. W. Clulow, *Colour, its Principles and Their Applications,* Fountain Press, London, 1972.

Ralph M. Evans, *An Introduction to Color,* Wiley-Interscience, New York, 1948.

R. W. G. Hunt, *The Reproduction of Colour,* 3rd Edn, Fountain Press, London, 1974.

D. B. Judd and G. Wyszecki, *Color in Business, Science and Industry,* 3rd Edn, Wiley-Interscience, New York, 1975.

C. A. Padgham and J. E. Saunders, *The Perception of Light and Colour,* G. Bell and Sons, London, 1975.

W. D. Wright, *The Measurement of Colour,* 4th Edn, Adam Hilger, London, 1969.

G. Wyszecki and W. S. Stiles, *Color Science,* Wiley-Interscience, New York, 1967.

Contributions to Color Science (the collected papers of the late Dr Deane B. Judd), Natl. Bur. Stds. (Washington DC) Special Publication 545, 1980.

SUBJECT INDEX